COOL SPOTS
MALLORCA / IBIZA

teNeues

Imprint

Editor: Eva Raventós

Photography: Roger Casas

Introduction: Eva Raventós

Layout & Pre-press: Oriol Serra Juncosa

Translations: Heather Bagott (English), Susanne Engler (German),
Michel Ficerai (French), Maurizio Siliato (Italian)

Produced by Loft Publications
www.loftpublications.com

Published by teNeues Publishing Group

teNeues Book Division
Kaistraße 18
40221 Düsseldorf, Germany
Tel.: 0049-(0)211-994597-0
Fax: 0049-(0)211-994597-40
E-mail: books@teneues.de

Press department:
arehn@teneues.de
Phone: 0049-2152-916-202

www.teneues.com

ISBN-10: 3-8327-9123-X
ISBN-13: 978-3-8327-9123-0
© 2006 teNeues Verlag GmbH + Co. KG, Kempen

Printed in Italy

teNeues Publishing Company
16 West 22nd Street
New York, NY 10010, USA
Tel.: 001-212-627-9090
Fax: 001-212-627-9511

teNeues Publishing UK Ltd.
P.O. Box 402
West Byfleet
KT14 7ZF, Great Britain
Tel.: 0044-1932-403509
Fax: 0044-1932-403514

teNeues France S.A.R.L.
4, rue de Valence
75005 Paris, France
Tel.: 0033-1-55766205
Fax: 0033-1-55766419

teNeues Ibérica S.L.
C/ Velazquez 57 6 Izd
28001 Madrid, Spain
Tel./Fax: 0034-6-57 13 21 33

Picture and text rights reserved for all countries.
No part of this publication may be reproduced in any manner whatsoever.

All rights reserved.

While we strive for utmost precision in every detail, we cannot be held responsible for any inaccuracies, neither for any subsequent loss or damage arising.

Bibliographic information published by Die Deutsche Bibliothek.
Die Deutsche Bibliothek lists this publication in the Deutsche Nationalbibliografie;
detailed bibliographic data is available in the Internet at http://dnb.ddb.de.

Contents	Page
Introduction	**5**

MALLORCA

Alinavida Lifestyle Store	10
Blond Café	12
Cas Ferrer Nou Hotelet	14
Corner for Clothes	18
Espléndido Hotel	20
Gran Hotel Son Net	22
Hotel Hospes Maricel	26
Hotel Mirabò de Valldemossa	32
Hotel Tres	36
Minimar Restaurant	40
Pasatiempos	42
Puro Beach Club	44
Puro Oasis Urbano	48
Restaurante Ublo	52
Son Brull Hotel & Spa	54
Torrent Fals	60
Virtual Beach Club	64
Mallorca Map	68

IBIZA

Agroturismo Can Parramatta	70
Atzaró	74
Bambuddha Grove	78
Blue Marlin	82
Boutique Hotel Ses Pitreras	86
Cala Comte	88
Cala Es Portixol	90
El Hotel Pachá	92
Es Vivé Hotel	98
Hotel Agroturismo Can Domo	102
Hotel Hacienda Na Xamena	108
Indize	112
KM5 Lounge	114
Kumharas Sunset Café	116
Pachá Ibiza	118
Ses Salines	122
Space	124
Villa Roca	128
Ibiza Map	134

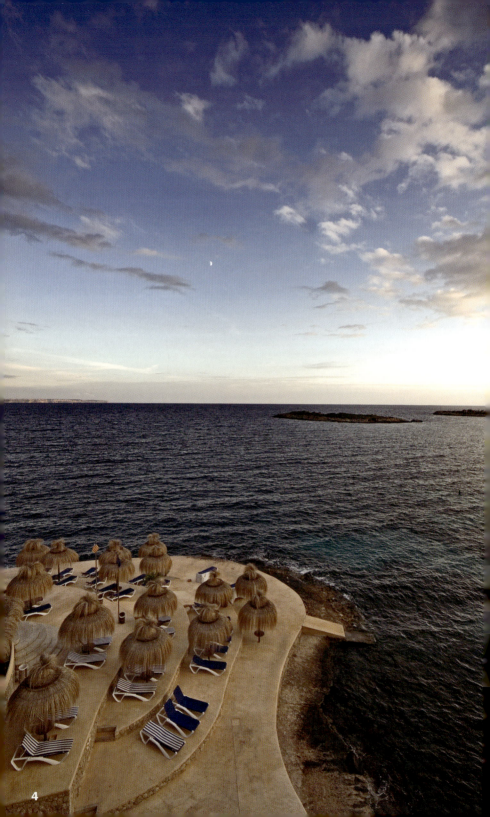

Introducción

Las islas siempre han representado una idea de vacaciones alejada de la de aquellos turistas incansables que viajan con un plan programado, sin pausa; son, en definitiva, un oasis de descanso y relajación en el que huir del estrés de la vida cotidiana. En el caso de Mallorca e Ibiza, este concepto ha evolucionado considerablemente desde los años sesenta, y estos destinos se han convertido en algo más que magníficas playas, vistas inmejorables y buena gastronomía, detalles que, a pesar de todo, siguen siendo esenciales a la hora de elegirlos como lugar de vacaciones.

A pesar de que han seguido una evolución común, Mallorca e Ibiza representan dos apuestas de viaje distintas: oasis de reposo y lugar idóneo para una escapada en familia, la primera, y capital de la vida nocturna y las relaciones públicas, la segunda, ambas islas han sabido adaptar con acierto sus rasgos originales a los nuevos tiempos.

En ambas islas hay multitud de rincones con encanto: locales con distintos espacios que ponen énfasis en la selección musical y en la creación de atmósferas, clubs de playa (que suelen incluir espacios *lounge* con tumbonas junto al mar, un restaurante y sus propios DJ), tiendas, discotecas (como las históricas Pachá y Space, que casi se han convertido en símbolos de Ibiza), calas, los populares "sunset cafés" (lugares donde contemplar la puesta del sol) o un nuevo concepto de establecimiento que, además de la venta, integra una galería de arte y un estudio de interiorismo (*lifestyle store*) son sólo algunas de las propuestas que ofrece esta selección dentro de la amplia oferta de las islas.

En definitiva, una breve guía de rincones, algunos ya clásicos y otros más novedosos y de reciente apertura, que confirman que Mallorca e Ibiza no son sólo un magnífico lugar de vacaciones sino también un estilo de vida que tiende, cada vez más –como viene siendo habitual en esta era posmoderna– a la fusión de ideas e influencias.

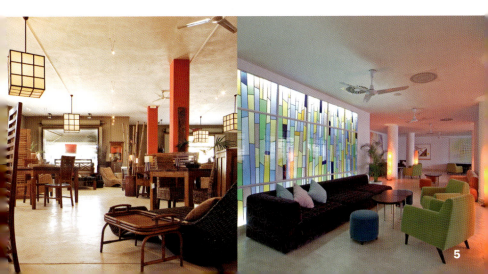

Introduction

The islands have always made for a different kind of holiday option. They provide an oasis of relaxation, somewhere to escape from the stress of daily life, a world away from the frenetic rhythm of tireless tourists. Majorca and Ibiza have evolved considerably since the sixties and both destinations have become something more than simply magnificent beaches, unbeatable views and good food, although such things are of course considered as an essential part of any holiday.
Though having evolved in a similar manner, Majorca and Ibiza offer different styles of holiday: the former is a tranquil haven and ideal for a family break whereas the latter is the Mecca of colorful night life and a renowned meeting point. Both have managed to adapt their original characteristics to modern day living.
In addition, both islands offer a myriad of charming spots: bars that place special emphasis on the selection of music and the creation of unique atmospheres, beach clubs (including lounge areas with deck chairs by the sea, restaurants and resident DJs) shops, nightclubs (such as the world famous Pachá and Space (which have practically become symbols of Ibiza), beach coves, sunset cafés (somewhere to enjoy the sun's descent into the sea), or the so called lifestyle stores (a new concept of place, combining art gallery, interior design studio and shop). These are just some of the many offerings available on these two islands. This is a collection of cool spots, some already classics and others newer to the scene. Confirming Majorca's and Ibiza's status as more than simply idyllic holiday destinations, but a way of life, which not surprisingly in today's world, is a fusion of ideas and influences.

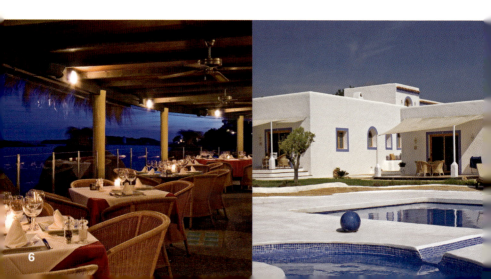

Einleitung

Ferien auf einer Insel wurden immer schon als eine entspanntere Art des Reisens aufgefasst: Wer sich auf eine Insel begibt, folgt nicht dem festen und übervollen Programm des unermüdlichen Touristen, sondern er sucht eine Oase der Ruhe und der Erholung, wo er dem Stress des täglichen Lebens entrinnen kann. Im Fall von Mallorca und Ibiza hat sich dieses Konzept seit den Sechzigerjahren stark gewandelt. Diese Inseln bedeuten als Reiseziel heutzutage mehr als nur wundervolle Strände, unvergleichliche Ausblicke und exzellente Küche, obwohl diese Eigenschaften nach wie vor ausschlaggebend dafür sind, den Urlaub auf diesen Inseln zu verbringen.

Obwohl Mallorca und Ibiza auf eine gemeinsame Entwicklung zurückblicken, sind sie doch zwei sehr verschiedene Reiseziele. Mallorca ist immer noch eine Oase der Ruhe und der ideale Ort, um einen Familienurlaub zu verbringen, während Ibiza die Hauptstadt des Nachtlebens ist, wo man viele neue Kontakte knüpft. Auf beiden Inseln hat man es verstanden, den ursprünglichen Charakter an die Gegenwart anzupassen.

Es gibt auf beiden Inseln viele bezaubernde Orte: Lokale mit verschiedenen Räumen, die Wert auf die Auswahl der Musik und auf außergewöhnliche Atmosphäre legen, Strandclubs, die über Loungebereiche am Meer mit Liegestühlen, Restaurants und eigene DJ's verfügen, Shops, Diskotheken (wie die bekannten Discos Pachá und Space, die fast zu Symbolen Ibizas geworden sind), Buchten, die berühmten „Sunset Cafés" (Orte, von denen aus man den Sonnenuntergang betrachten kann) oder neuartige Lokale, in denen es außer einem Shop auch eine Kunstgalerie und ein Innenarchitekturstudio gibt, so genannte *Lifestyle Stores.* Das ist nur eine kleine Auswahl aus dem reichhaltigen Angebot der Inseln. Dieses Buch gibt einen Überblick über die interessantesten Plätze auf den Inseln, einige davon sind Klassiker, andere vollkommen neu. Ein Beweis dafür, dass Mallorca und Ibiza nicht nur wundervolle Urlaubsorte sind, sondern auch für einen Lebensstil stehen, der den Trends der postmodernen Ära entsprechend eine Vermischung verschiedener Ideen und Einflüsse beinhaltet.

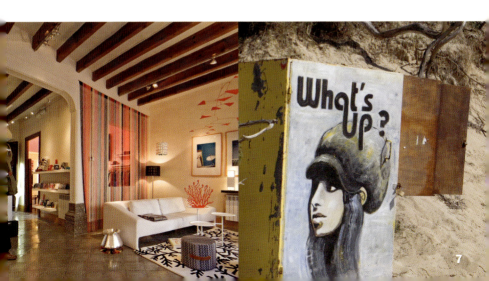

Introduction

Les îles ont toujours représenté une idée de vacances différentes de celles de ces touristes infatigables en voyage organisé. Elles sont en effet plus une oasis de repos et de détente où fuir le stress de la vie quotidienne. Pour Majorque et Ibiza, ce concept a évolué considérablement depuis les années soixante. Ces destinations sont devenues plus que de magnifiques plages, des vues imprenables et une bonne gastronomie. Des détails qui, cependant, demeurent essentiels à l'heure de les choisir comme lieu de vacances.
Bien qu'elles aient suivi une évolution commune, Majorque et Ibiza représentent deux concepts de voyage distincts : oasis de repos et site idéal pour une escapade en famille pour l'un et capitale de la vie nocturne et des relations publiques pour l'autre, les deux îles ont su adapter avec pertinence leurs traits originaux aux temps modernes.
Les deux îles connaissent une multitude de petits coins enchanteurs : des lieux dotés d'espaces distincts mettant l'accent sur la sélection musicale et la création d'atmosphères, des clubs de plage (qui comprennent habituellement des espaces *lounge* avec des transats au bord de la mer, un restaurant et un DJ maison), des boutiques, des discothèques (comme les historiques Pachá et Space, qui se sont presque convertis en symboles d'Ibiza), des criques, les populaires « sunset cafés » (pour s'abandonner à la contemplation du coucher du soleil) ou un nouveau concept d'établissement qui, outre la vente, intègre une galerie d'art et un atelier de design d'intérieur : les *lifestyle stores* ; ces exemples ne sont que quelques unes des propositions de cette petite sélection au cœur de la vaste palette qu'offre les îles. Ceci est donc un échantillon de sites, certains déjà classiques et d'autres plus novateurs et récemment ouverts, qui confirment que Majorque et Ibiza ne sont pas simplement de magnifiques destinations de vacances mais aussi un style de vie qui tend chaque jour davantage – comme c'est de plus en plus habituel dans notre ère post-moderne – à la fusion d'idées et d'influences venants de toutes parts.

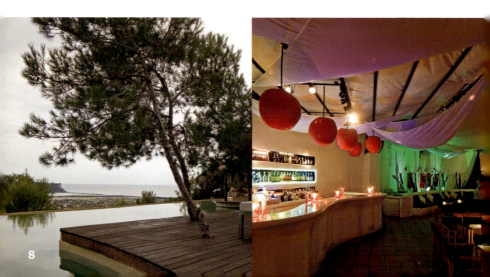

Introduzione

Da sempre le isole sono state associate ad un'idea di vacanza diversa da quella dei tipici turisti instancabili che seguono un programma prestabilito e che non gli lascia un attimo di respiro: in definitiva, le isole sono un'oasi di relax dove riposare e fuggire momentaneamente dallo stress della vita quotidiana. Nel caso di Maiorca ed Ibiza, dagli anni sessanta fino ad oggi questo concetto si è evoluto notevolmente, e queste due mete adesso offrono molto di più che magnifiche spiagge, vedute insuperabili e una buona gastronomia. Anche se queste attrattive continuano indubbiamente ad essere determinanti per chi le sceglie come luogo dove trascorrerci le proprie vacanze.

Nonostante abbiano seguito un'evoluzione comune, Maiorca ed Ibiza rappresentano due concetti di viaggio diversi: oasi di riposo e luogo idoneo per una breve vacanza in famiglia la prima, e capitale della vita notturna e delle opportunità per conoscere gente nuova la seconda. Entrambe le isole sono riuscite ad adattare, con ottimi risultati, i loro tratti peculiari ai nuovi tempi e alle nuove esigenze.

Alle strutture turistiche si affiancano anche numerosi luoghi ed angoli affascinanti; locali che dispongono di diversi ambienti a seconda del tipo di musica e di atmosfera, club in riva al mare (di solito includono spazi *lounge* con sedie a sdraio, un ristorante e i loro propri DJ), negozi e discoteche all'ultimo grido (come le storiche Pachá e Space, due autentici simboli della moderna Ibiza). Ma non è tutto: insenature incontaminate, i popolari "sunset cafe" (luoghi dove contemplare il tramonto) o un nuovo concetto di esercizio commerciale – i *lifestyle stores* –, che oltre alla vendita ingloba una galleria d'arte e uno studio di interior design sono soltanto alcune delle proposte raccolte in questa selezione che rientrano nella vasta gamma di offerte di cui vantano le due isole. In definitiva, guida che vi aiuterà a scoprire alcuni tra i più suggestivi angoli delle isole, alcuni diventati ormai dei classici ed altri di recente apertura. Il tutto per dimostrare che Maiorca ed Ibiza non sono solo una rinomata meta vacanziera ma anche uno stile di vita che tende ad essere sempre di più – com'è abituale in questa era postmoderna – una fusione di influenze e idee.

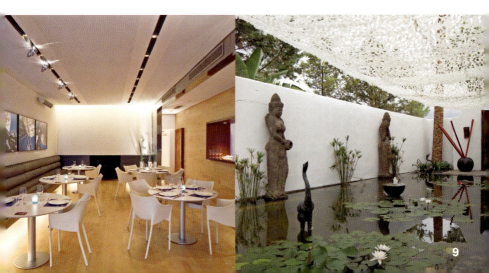

Alinavida
Lifestyle Store

Design: Alinavida Interior Design (Elma Choung, Harald Adler)

c/ Santanyí, 12 | 07630 Campos, Mallorca
Phone: +34 971 651 594
www.alinavida.com
Opening hours: Summer, Tue–Fri 10 am to 6 pm, Sat 10 am to 1 pm; winter, Tue–Fri 10 am to 1 pm, 5 pm to 8 pm, Sat 10 am to 1 pm
Special features: Gallery. Interior Design. Offering contemporary furniture, household accessories, office furniture, lighting, fashion, music, a wide variety of teas, etc.

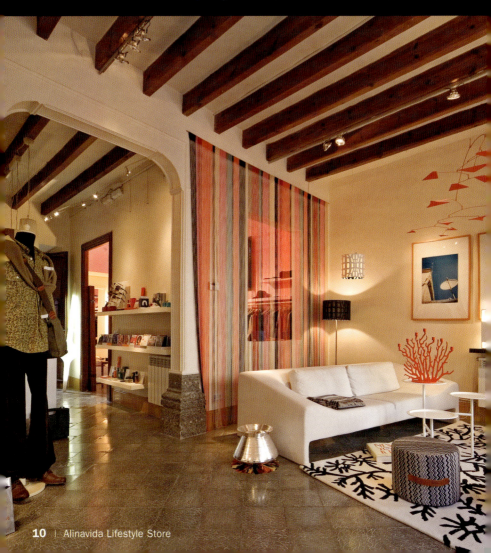

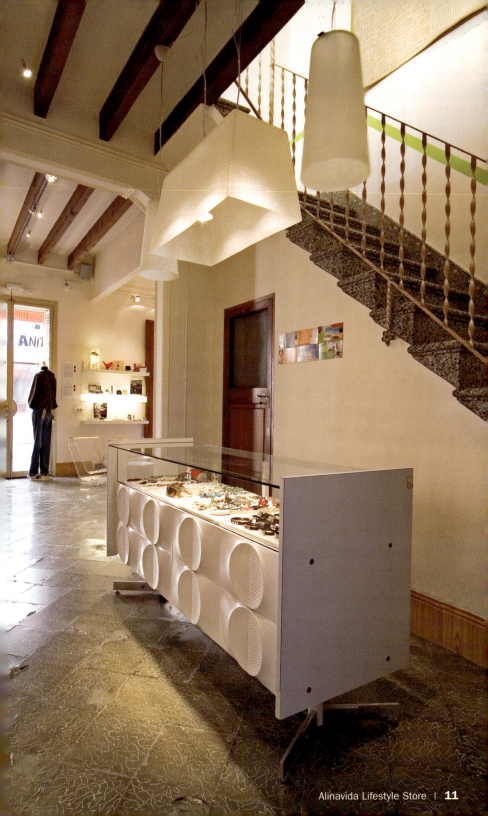

Blond Café

Design: Christian Aronsen

Pza. Salvador Coll, 10 | 07001 Palma de Mallorca, Mallorca
Phone: +34 971 213 646
www.blondcafe.com
Opening hours: Mon–Sat 9 am to 10 pm
Special features: Different ambiences for dining (fusion cuisine), having a drink, listening to music (DJ sets), creating or just relaxing. Great selection of coffees

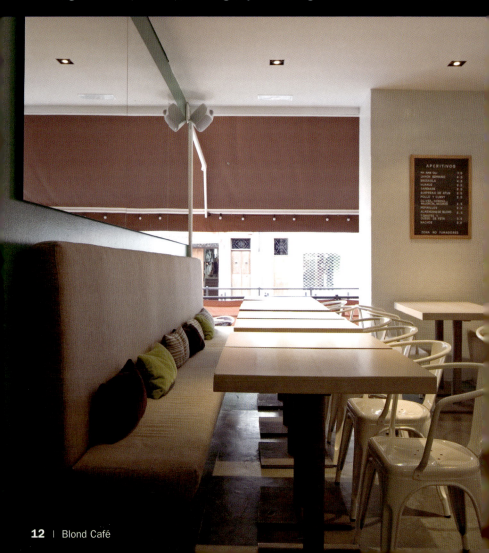

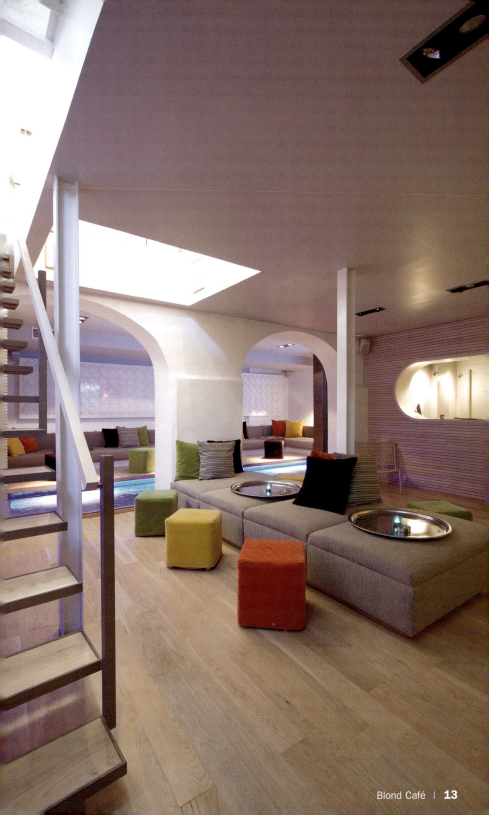

Cas Ferrer
Nou Hotelet

Architect: Pepe Reynés | Design: Jaume Poma, Tolo Llabrés

c/ Pou Nou, 1 | 07400 Alcúdia, Mallorca
Phone: +34 971 897 542
www.nouhotelet.com
Opening hours: Every day 8 am to 3 pm, 7 pm to 10 pm
Special features: A restored antique forge where each room boasts a different atmosphere, color and concept, drawing inspirations from artists and places of Mediterranean culture: L'Alguer, Pollentia, Botticelli, Safo, Cavafis, Istanbul

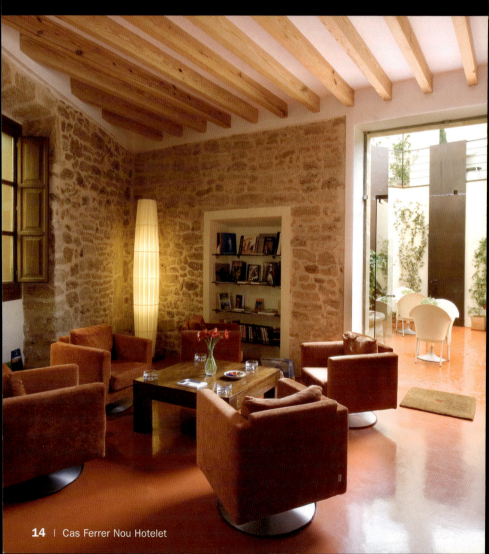

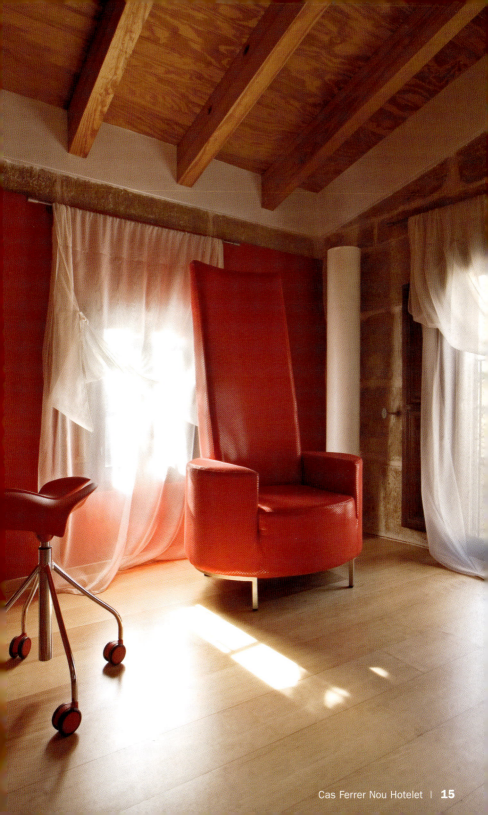

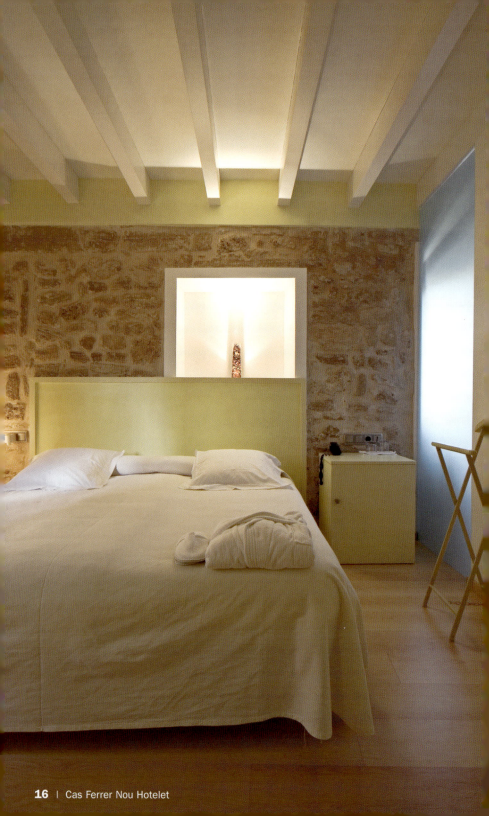

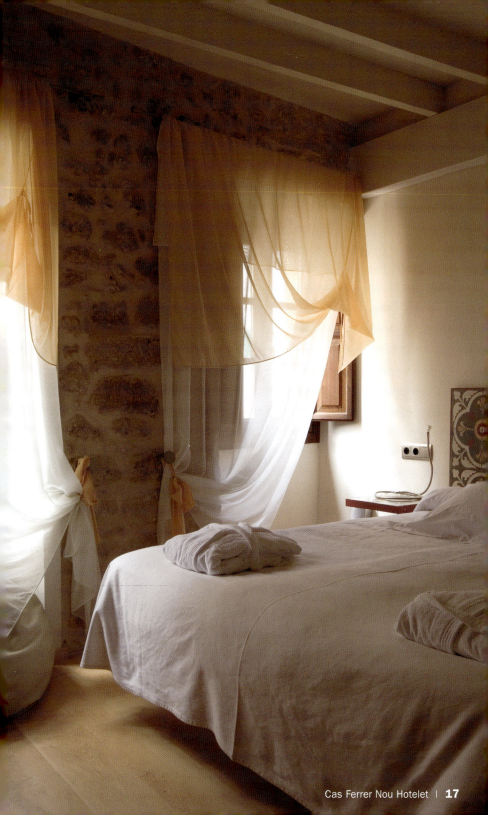

Corner for Clothes

Architects: Juan Pol, Juan Verger

P.º del Born, 10 | 07012 Palma de Mallorca, Mallorca
Phone: +34 971 425 514
www.cornerforclothes.com
Opening hours: Mon–Sat 10 am to 8:30 pm
Special features: Avant-garde collections and designer shoes and accessories for men and women

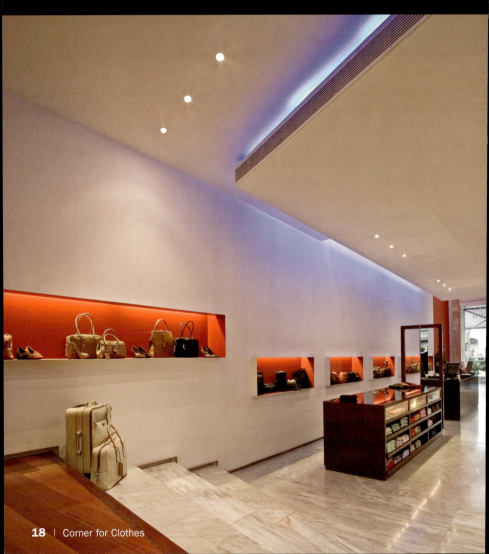

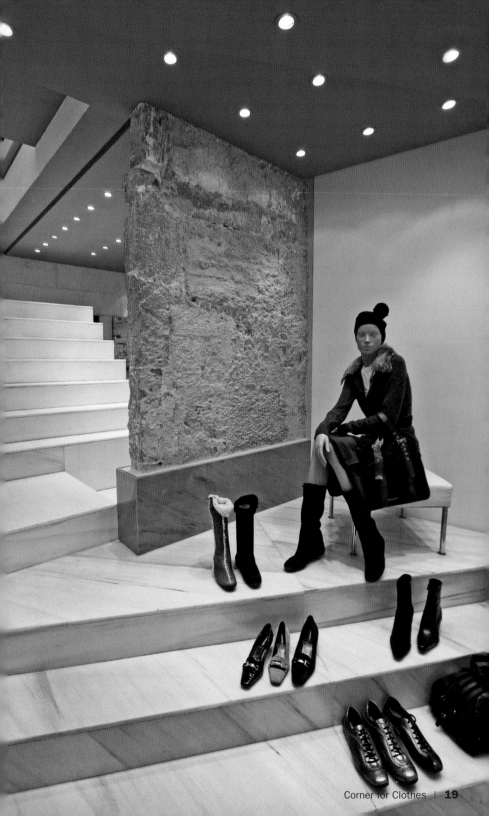

Espléndido Hotel

Architect: Rafael Vidal | Design: Johanna & Mikael Landström

c/ Es Traves, 5 | 07108 Port de Sóller, Mallorca
Phone: +34 971 631 850
www.esplendidohotel.com
Opening hours: Every day, open 24 hours
Special features: Swimming pool overlooking the sea, health club with beauty salon and massage, Finnish & Turkish sauna, relaxing terrace with Jacuzzi

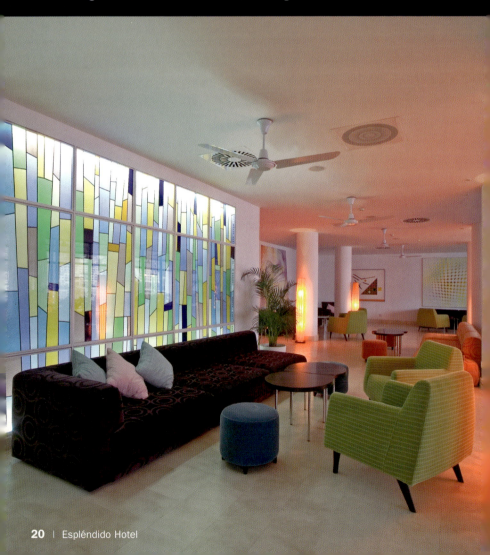

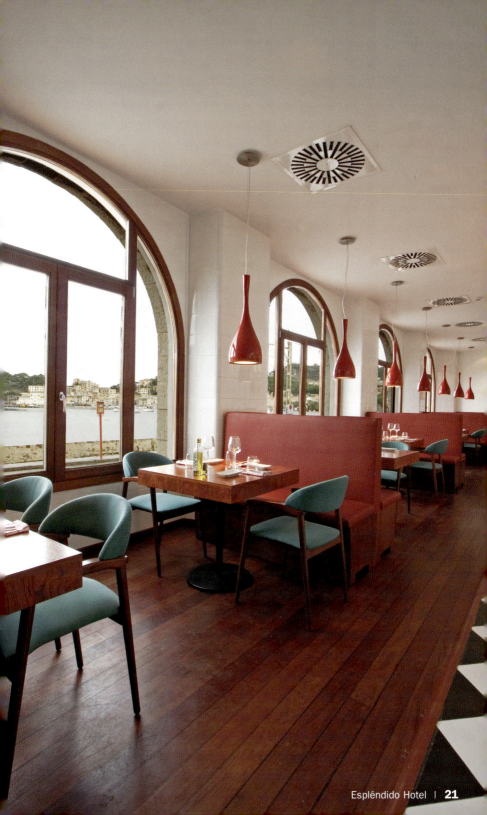

Gran Hotel Son Net

Design: The Stein Group

c/ Castillo de Sonnet s/n | 07194 Puigpunyent, Mallorca
Phone: +34 971 147 000
www.sonnet.es
Opening hours: Every day, open 24 hours
Special features: A 17th century castle that served as a country retreat for an aristocratic family, housing an art collection where works by Andy Warhol, David Hockney and Marc Chagall can be enjoyed

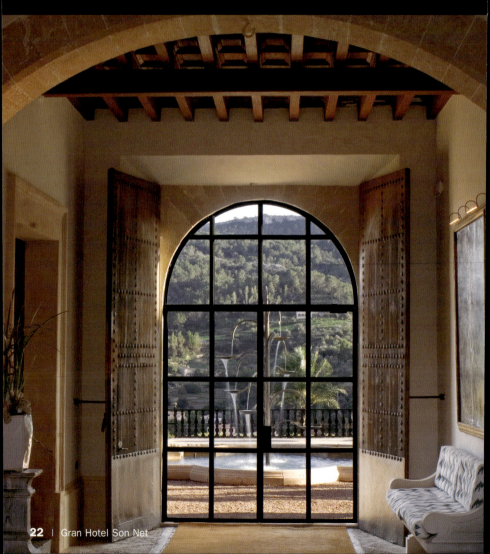

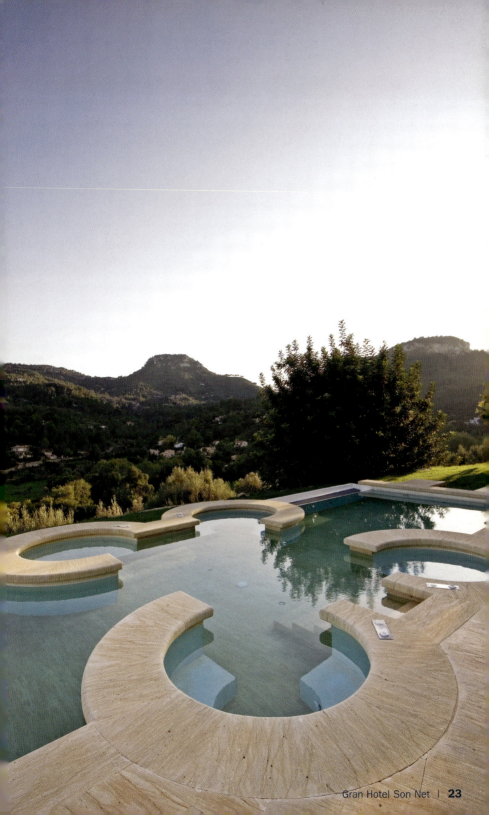

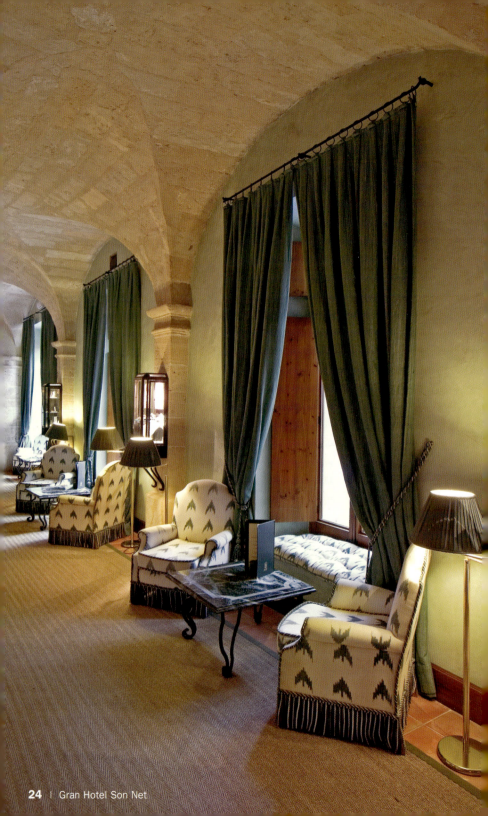

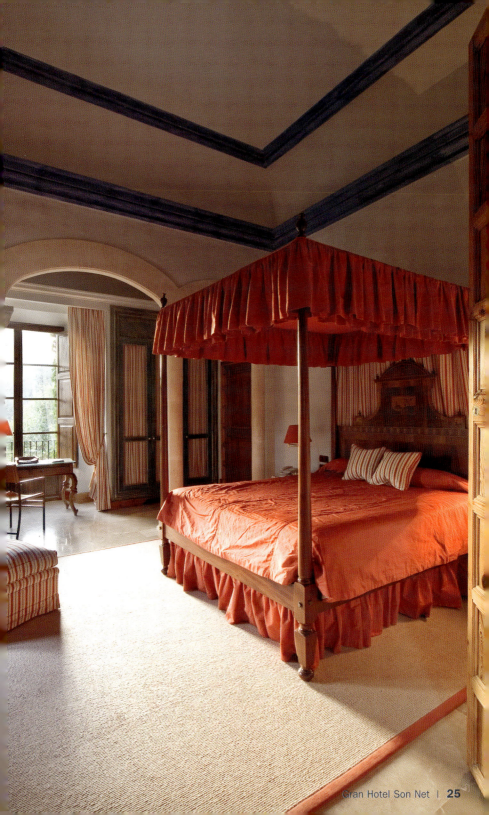

Hotel Hospes Maricel

Design: Hospes Design

Ctra. d'Andratx, 11 | 07184 Calvià, Mallorca
Phone: +34 971 707 744
www.hospes.es
Opening hours: Senzone Cocktail Bar, Sun–Wed 4 pm to 1 am,
Thu–Sat 4 pm to 2 am. Bodyna Spa & Sensations, 10:30 am
to 8:30 pm (only in the summer)
Special features: A number of terraces with stunning views and a spa overlooking the sea. Live jazz on Thursdays at the Senzone Cocktail Bar

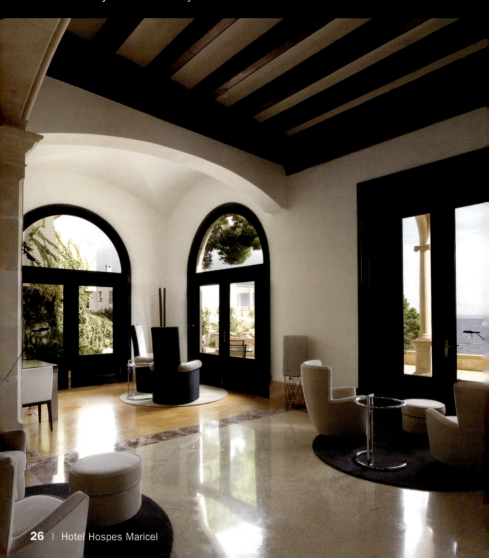

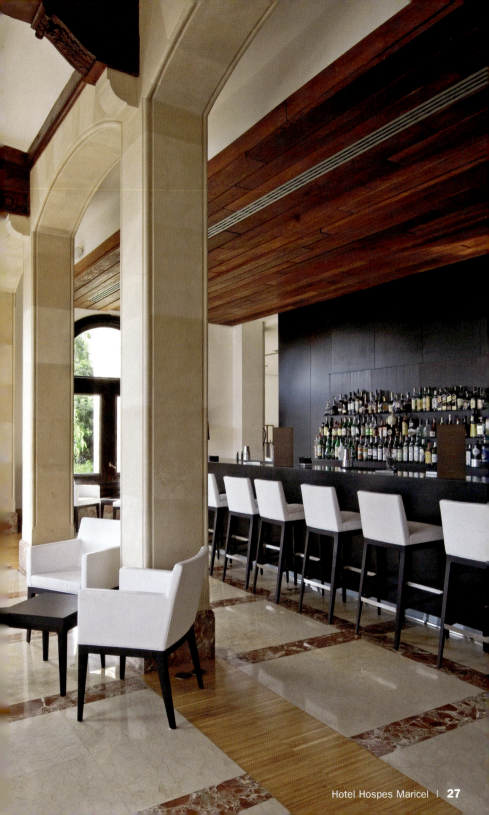

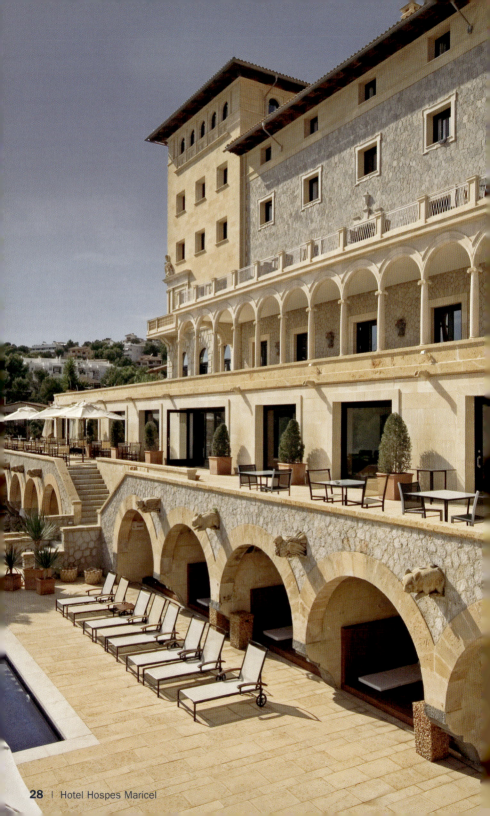

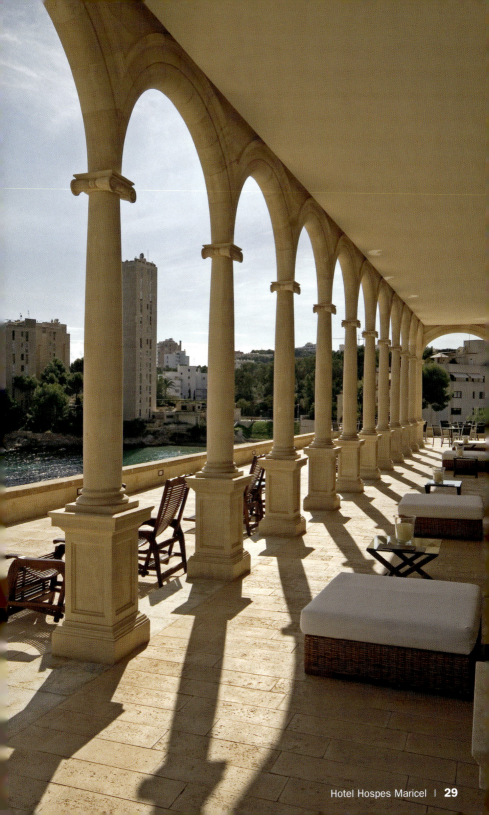

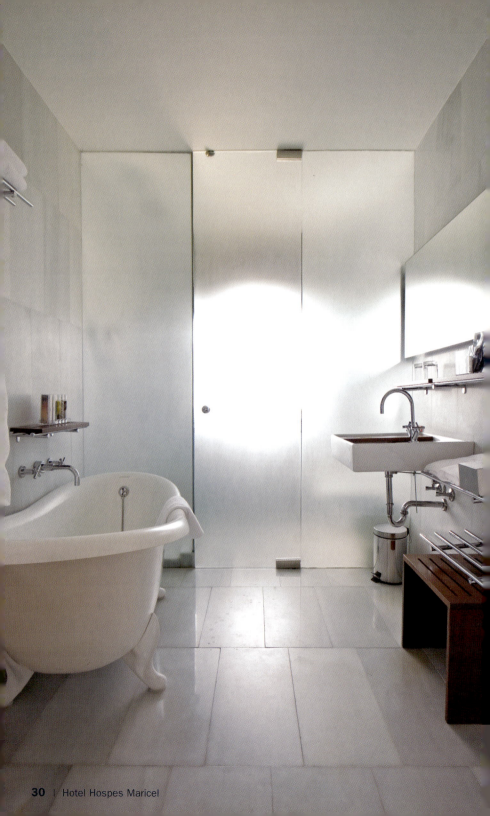

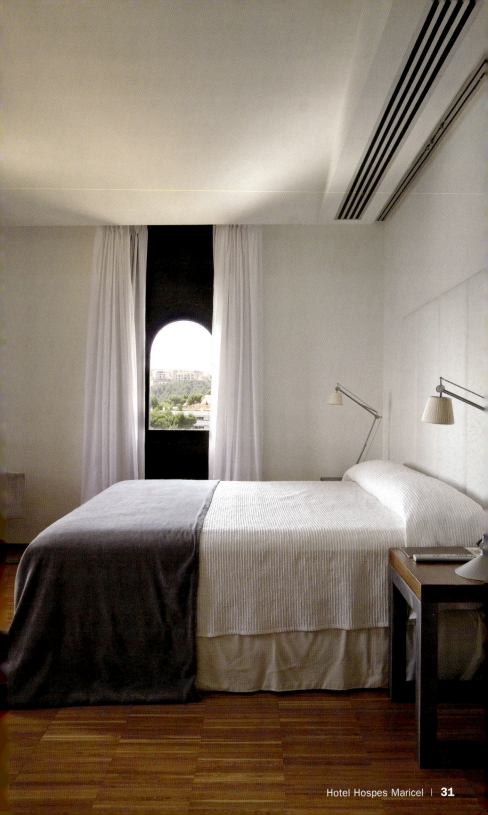

Hotel Mirabò
de Valldemossa

Design: José Ozonas, Paola Oyarzábal

Ctra. Valldemossa, km 15,950 | 07170 Valldemossa, Mallorca
Phone: +34 661 285 215
www.mirabo.es
Opening hours: Every day 10 am to 2 pm
Special features: A 15th century house offering large rooms with private terraces

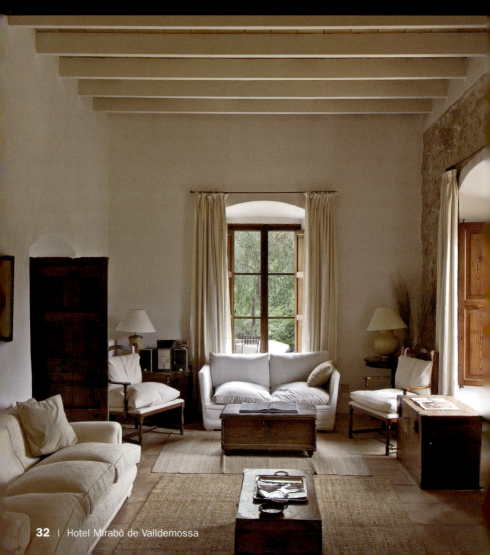

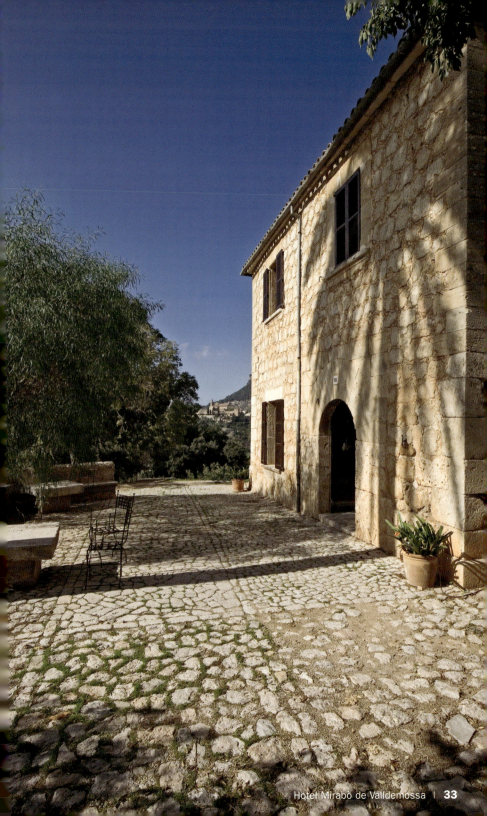

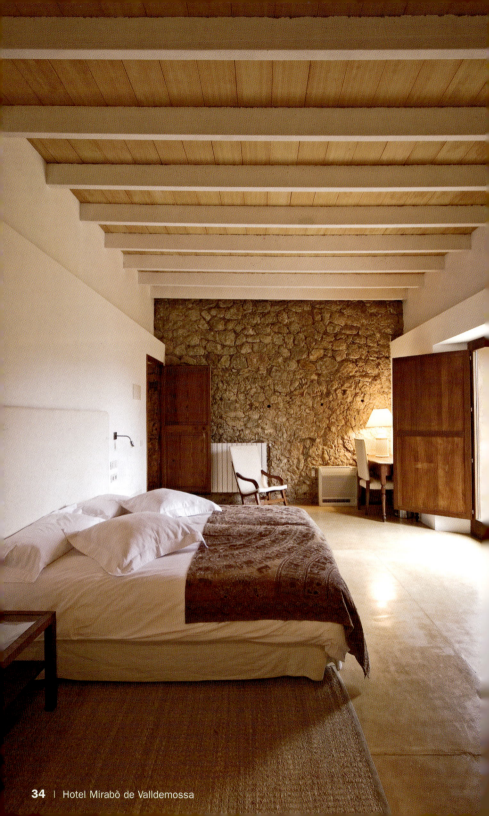

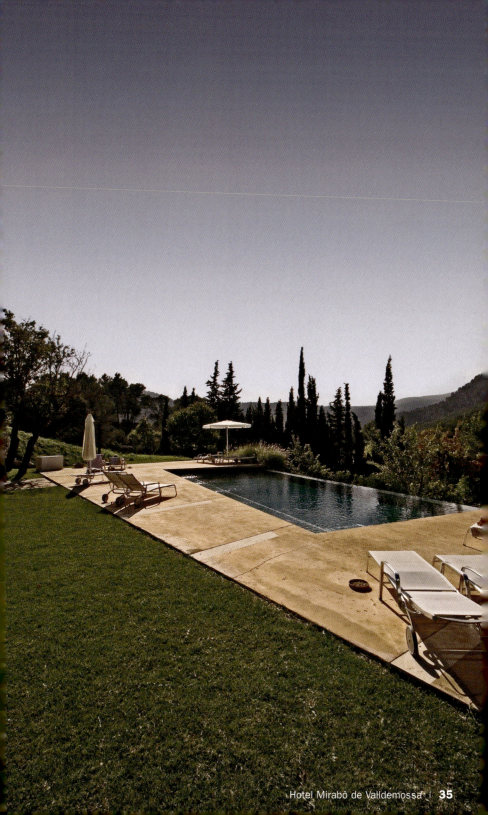

Hotel Tres

Design: Tomas Grip, Anders Stjärna, Antonio Pérez Villegas

c/ Apuntadores, 3 | 07012 Palma de Mallorca, Mallorca
Phone: +34 971 717 333
www.hoteltres.com
Opening hours: Every day, open 24 hours
Special features: A mix of traditional Majorcan style and modern, cutting edge design, boasting a terrace with swimming pool and stunning views

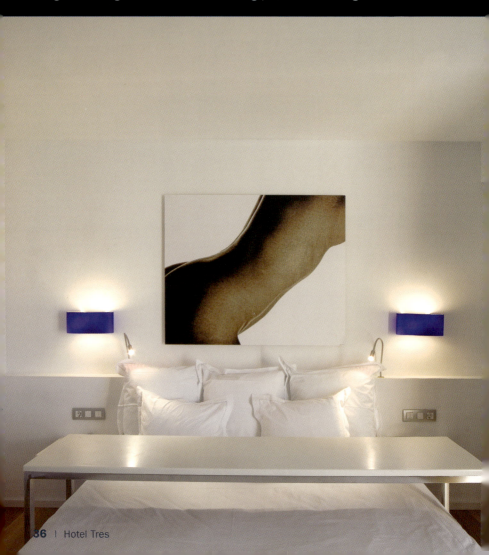

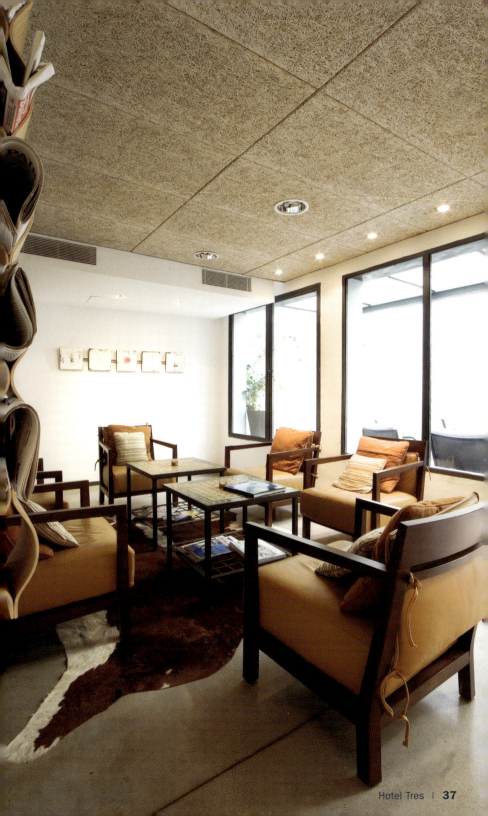

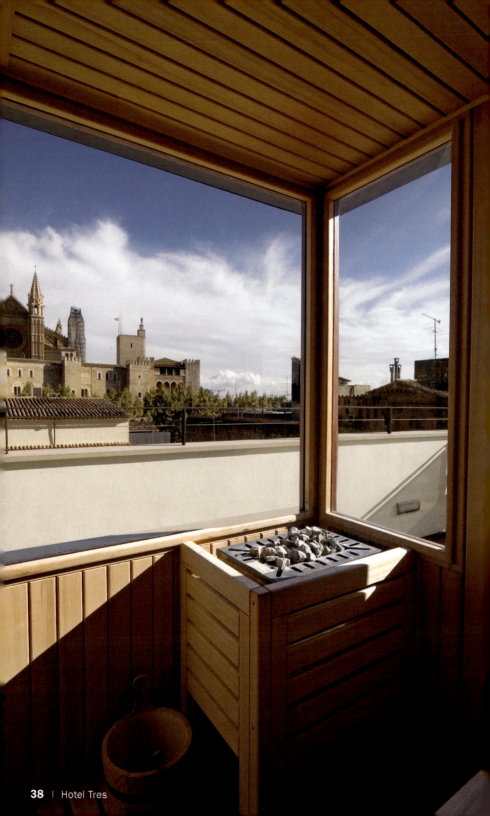

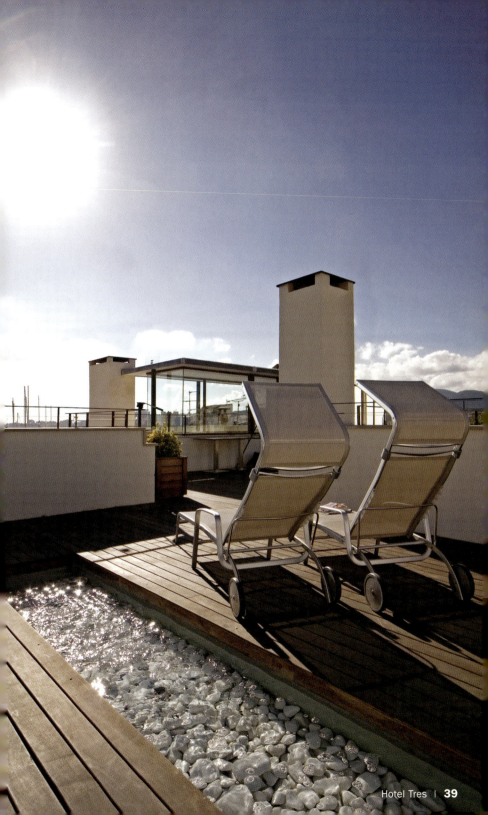

Minimar Restaurant

Design: Isabel Jover

Puerto Portals, 18 | 07181 Calvià, Mallorca
Phone: +34 971 677 337
Opening hours: Every day 1 pm to 4 pm, 7:30 pm to 11:30 pm
Special features: "Pintxos", tapas and seafood. Minimalist design

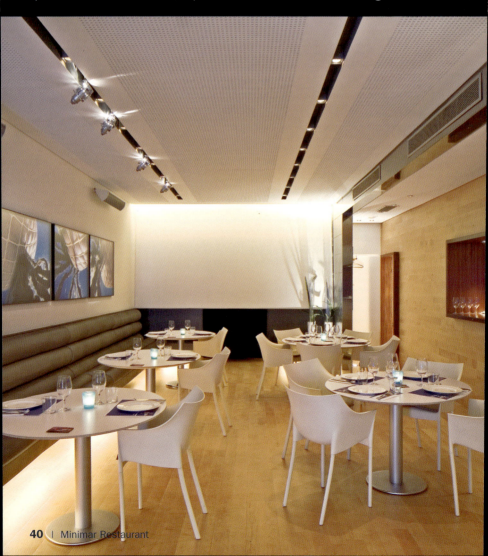

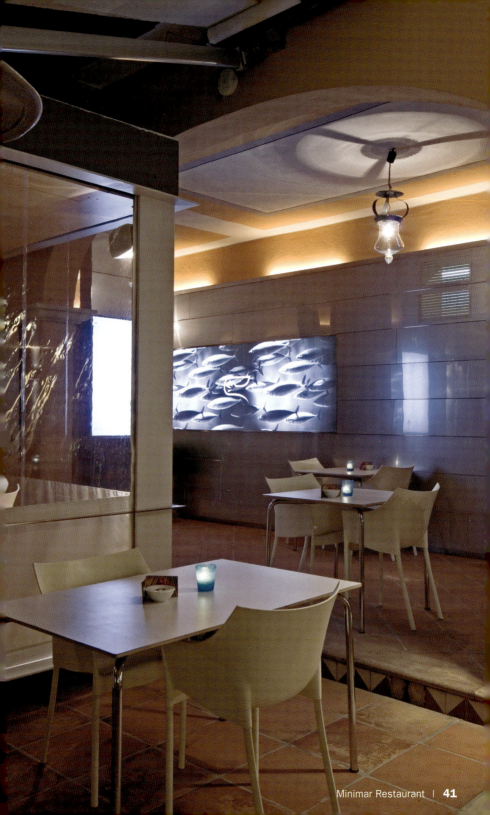

Pasatiempos

Design: Pasatiempos

c/ Quint, 3 | 07001 Palma de Mallorca, Mallorca
Phone: +34 971 725 980
www.pasatiempos.net
Opening hours: Mon–Sat 10 am to 8 pm
Special features: Prestigious brands such as Carhartt, Diesel, Converse, as well as T-shirts with home brand designs and original, customized handbags and ties

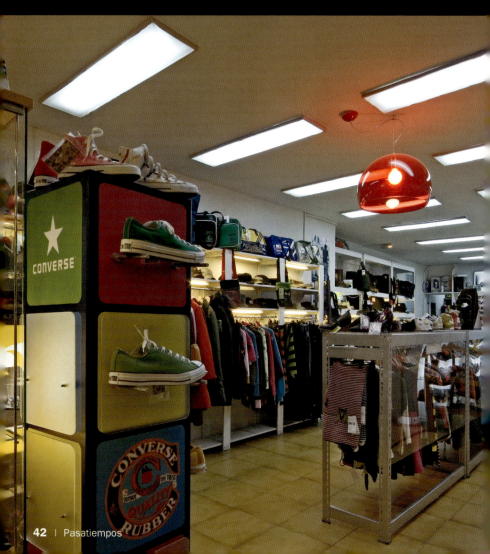

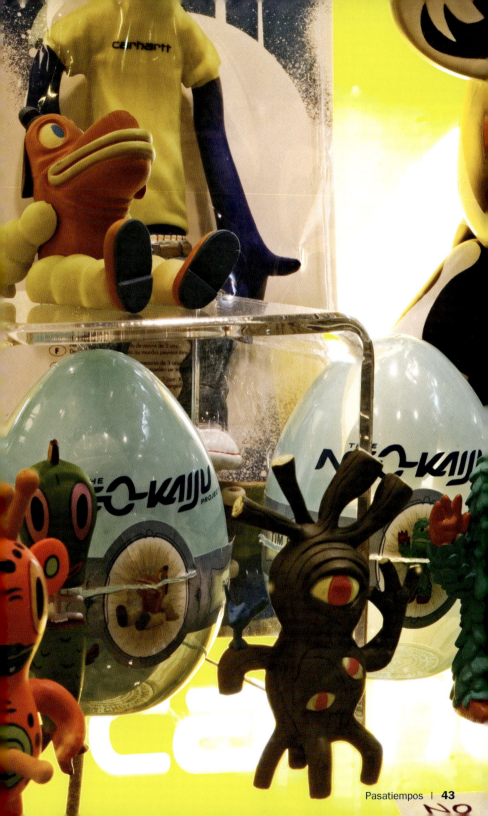

Puro Beach Club

Design: Gabrielle Jangeby

c/ Pagell, 1, Cala Estancia | 07610 Palma de Mallorca, Mallorca
Phone: +34 971 744 744
www.purobeach.com
Opening hours: Spa, 9 am to 6 pm; pool, 9 am until sunset; bar & restaurant, 9 am to noon (breakfast menu), noon to midnight (lunch, dinner and pool menu)
Special features: Beach club including spa & yoga, pool, lounge, restaurant & bar

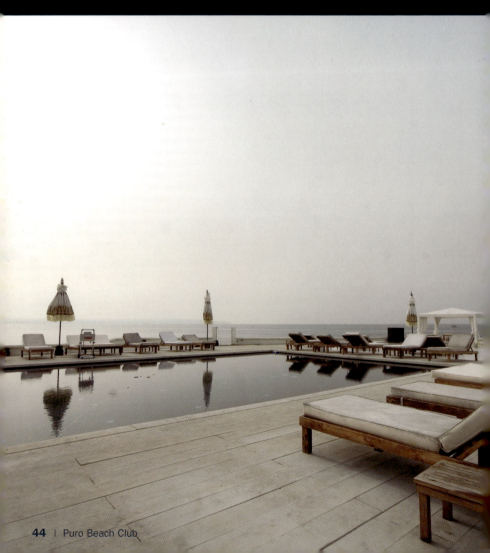

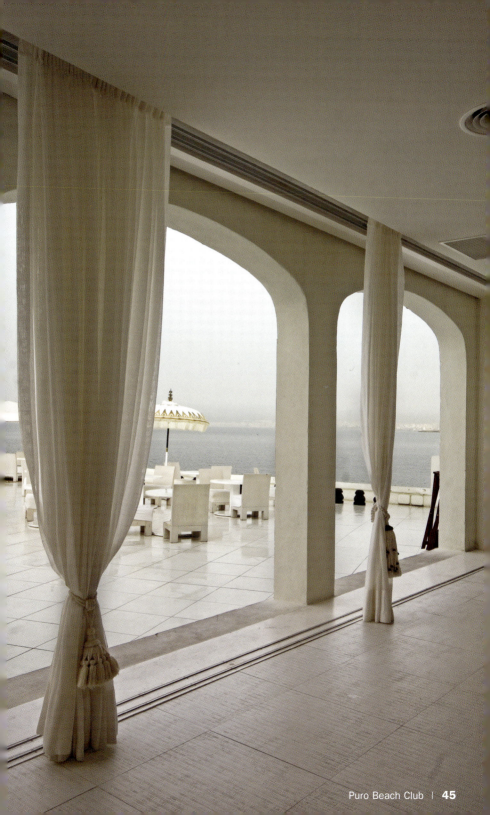

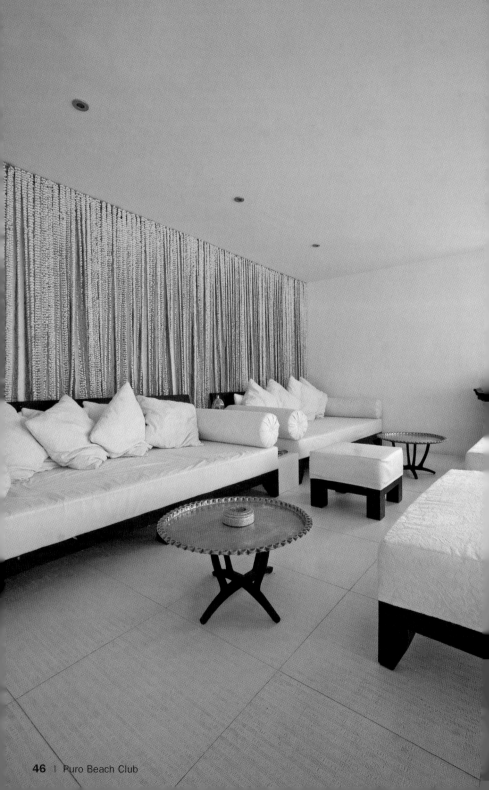

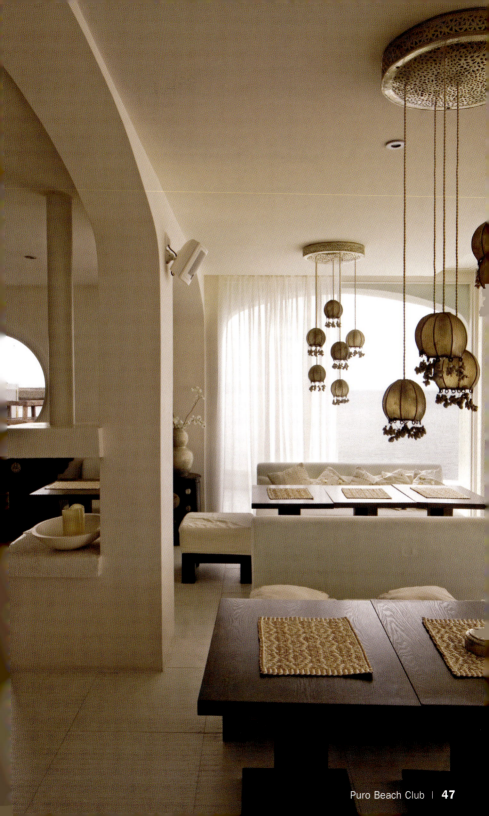

Puro Oasis Urbano

Architect: Álvaro Planchuelo | Design: K+E Interior Design

c/ Montenegro, 12 | 07012 Palma de Mallorca, Mallorca
Phone: +34 971 425 450
www.purohotel.com
Opening hours: Every day, open 24 hours
Special features: The hotel is a 14th century palace restored for modern living in an urban, Mediterranean setting

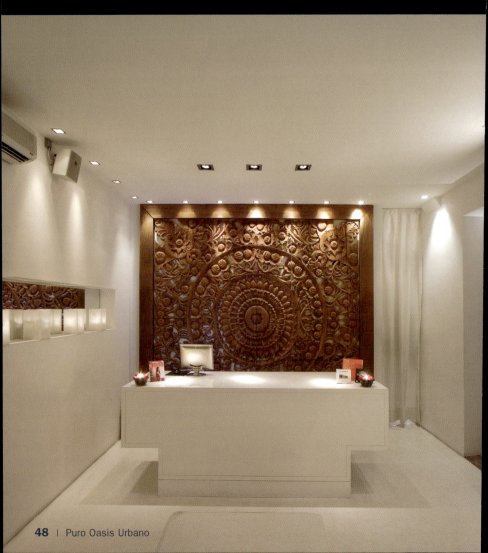

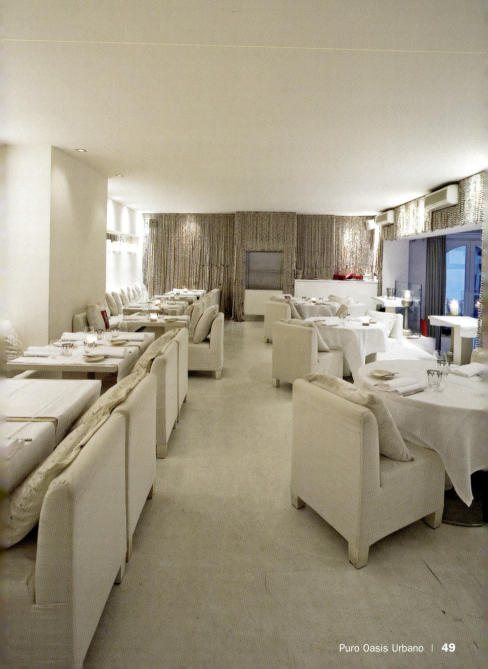

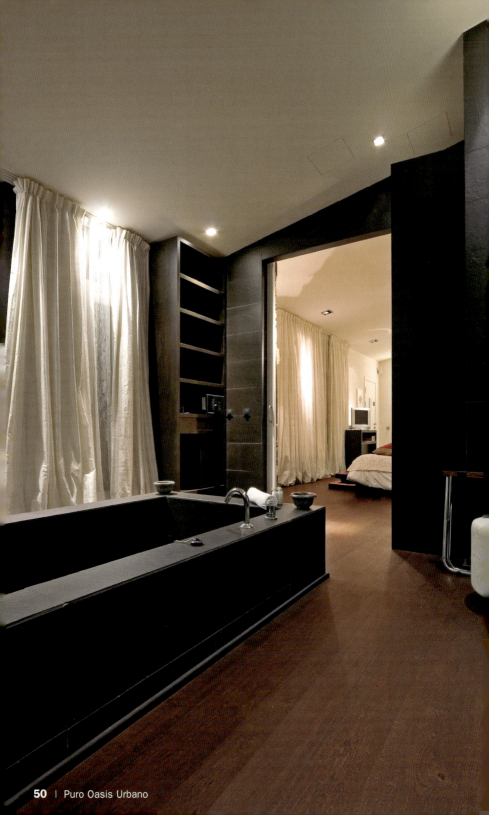

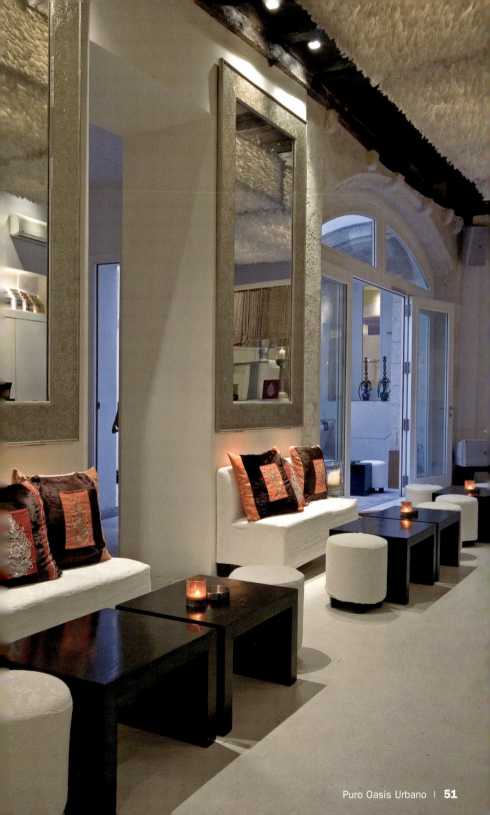

Restaurante Ublo

Design: Moble Asimètric

Pza. Progreso, 23 | 07013 Palma de Mallorca, Mallorca
Phone: +34 971 903 013
Opening hours: Mon–Sat 1:30 pm to 4 pm, 8:30 pm to midnight
Special features: New restaurant which offers lobster tasting in a space that creates a sense of intimacy produced by subdued lighting

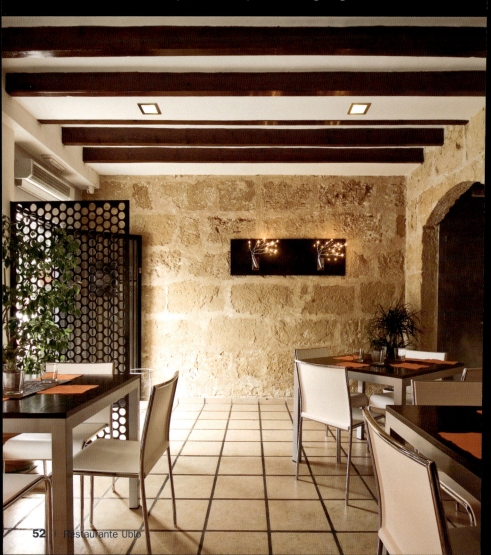

Son Brull
Hotel & Spa

Architect: Ignasi Forteza

Ctra. Palma-Pollença PM 220, km 49,8 | 07460 Pollença, Mallorca
Phone: +34 971 535 353
www.sonbrull.com
Opening hours: Every day, open 24 hours
Special features: A restored, 18th century monastery, converted into a 5 star hotel with an open air chill out & lounge bar open in summer

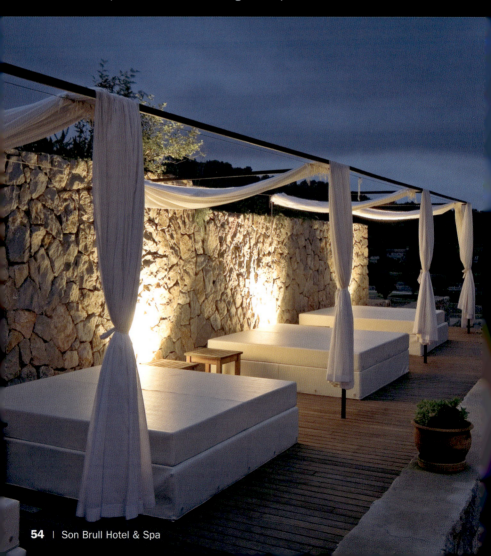

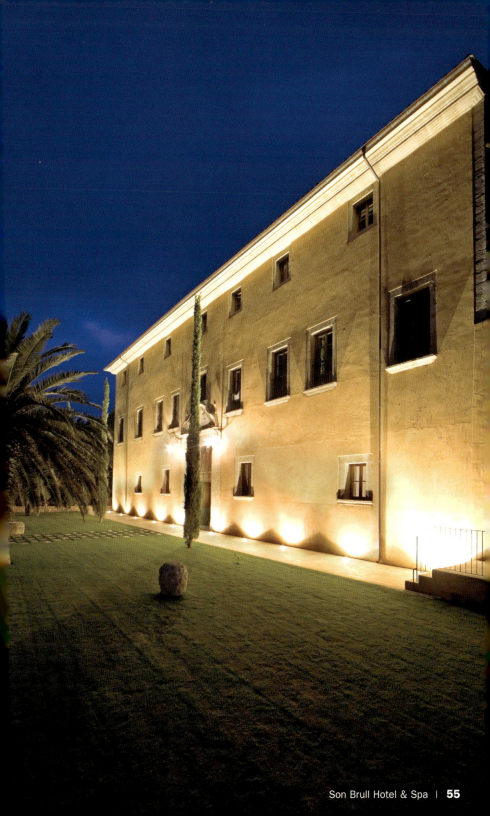

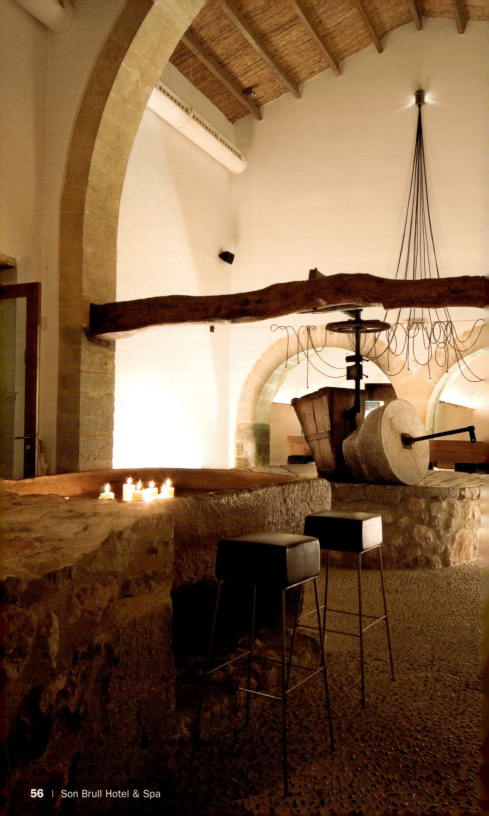

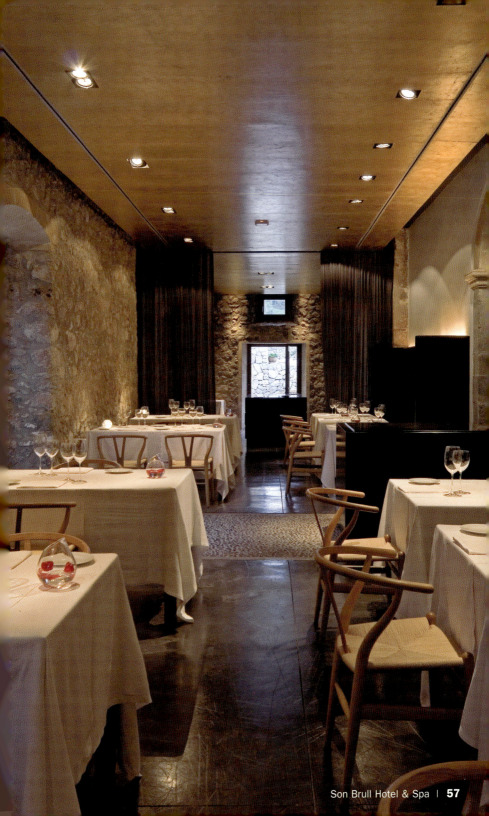

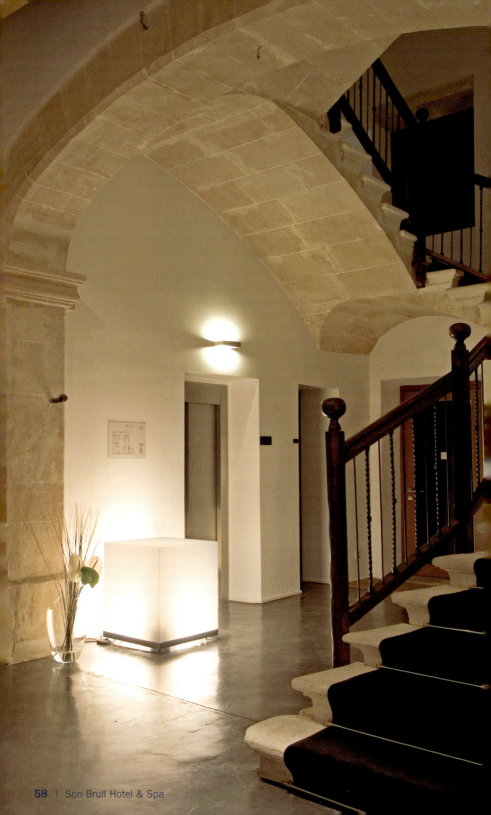

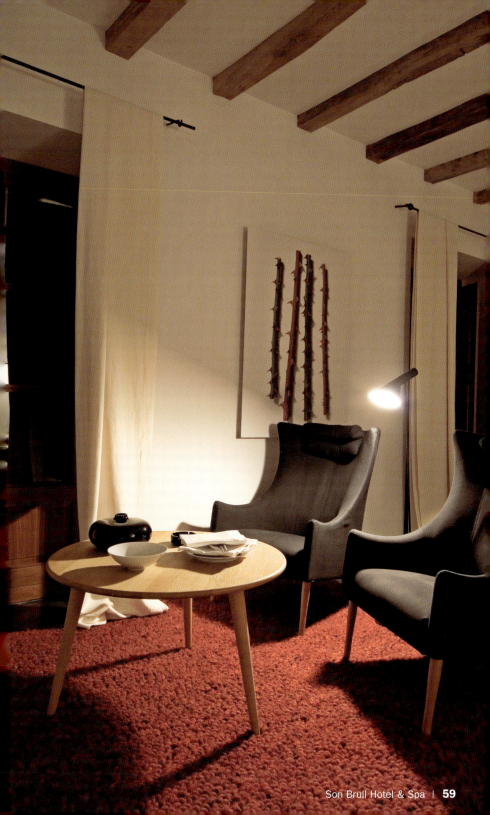

Torrent Fals

Design: Antonio Obrador

Ctra. Santa Maria-Sencelles, km 4,5 | 07320 Santa Maria del Camí, Mallorca
Phone: +34 971 144 584
www.torrentfals.com
Opening hours: Every day, open 24 hours
Special features: 15th century building restored in the style of Borgoña wineries with a large swimming pool and wine cellar

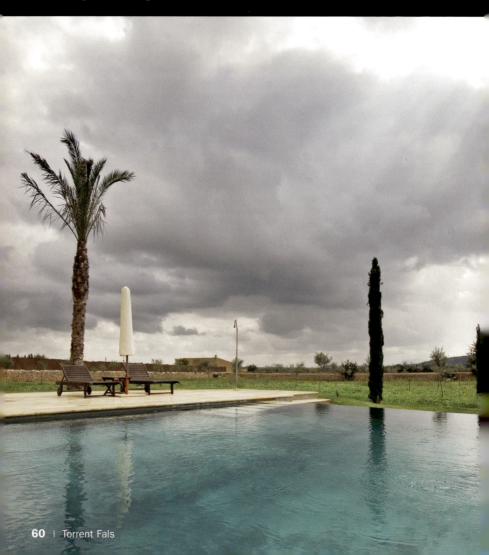

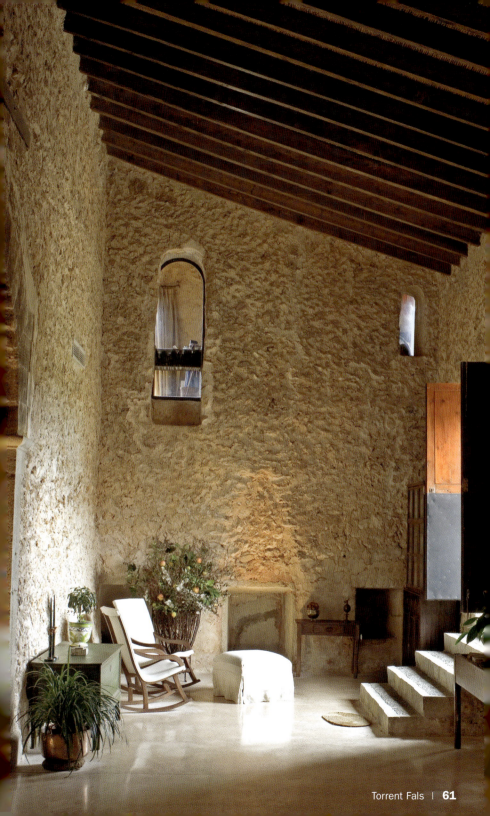

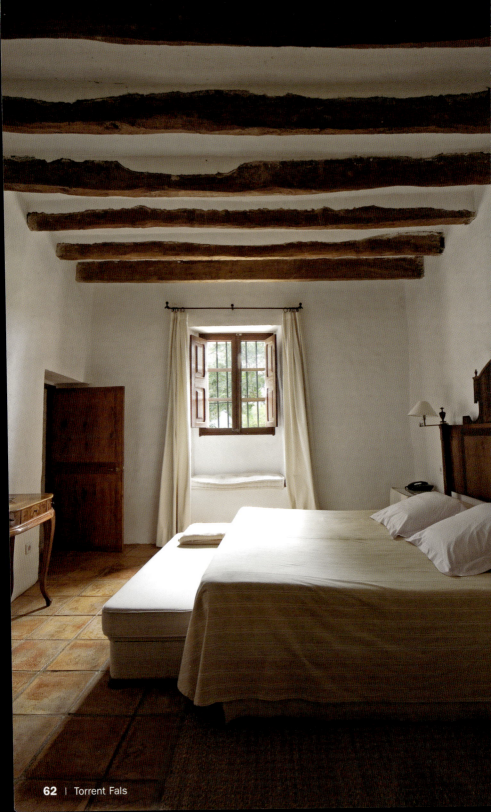

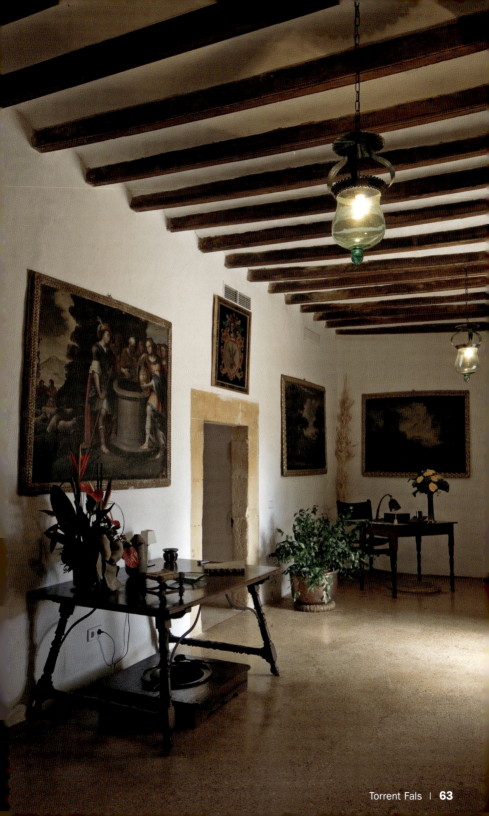

Virtual Beach Club

Design: Virtual Club team

P.º Illetas, 60 | 07181 Calvià, Mallorca
Phone: +34 971 703 235
www.virtualclub.es
Opening hours: 10 am to 3 am. The club opens all year on Fridays and Saturdays. Bar and restaurant closed from the 15th of October to the 15th of May
Special features: Restaurant with fusion cuisine and theme nights boasting outdoor cocktail bar and sun loungers by the sea

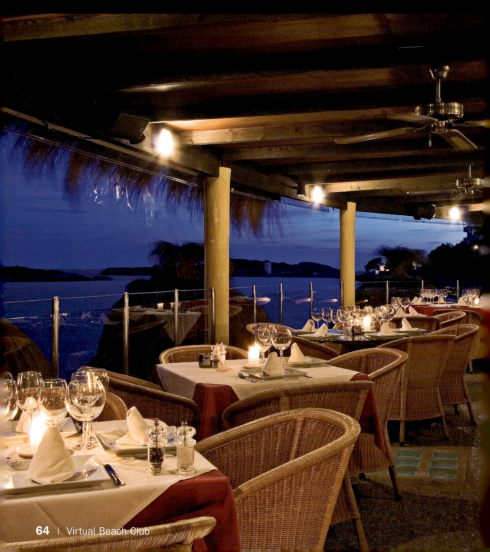

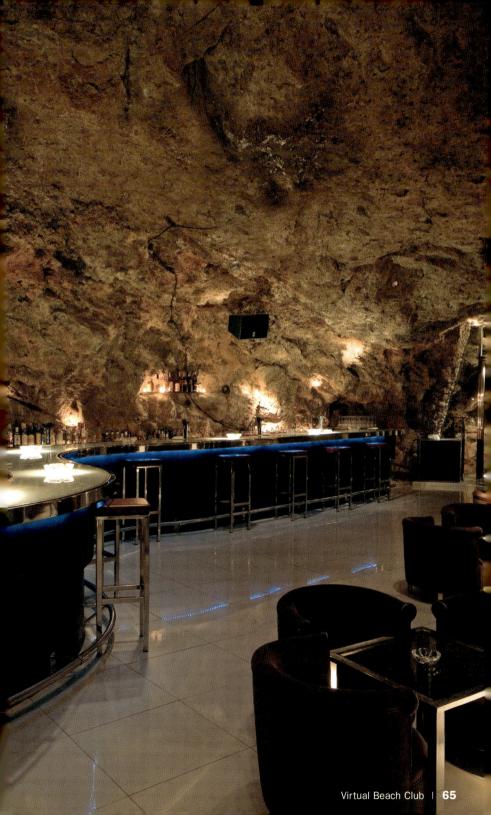

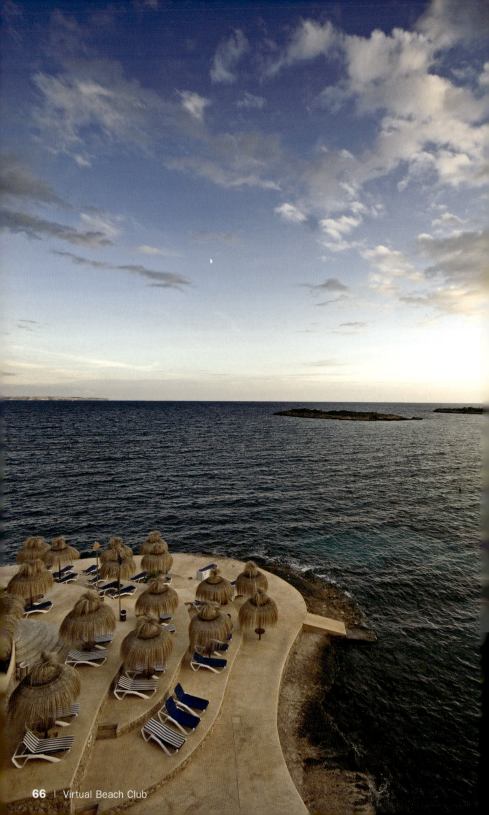

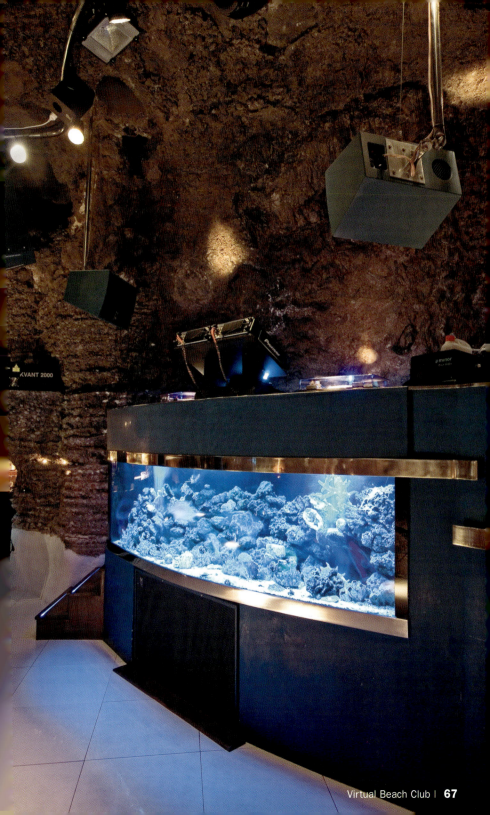

No.		Page
1	Alinavida Lifestyle Store	10
2	Blond Café	12
3	Cas Ferrer Nou Hotelet	14
4	Corner for Clothes	18
5	Espléndido Hotel	20
6	Gran Hotel Son Net	22
7	Hotel Hospes Maricel	26
8	Hotel Mirabò de Valldemossa	32
9	Hotel Tres	36
10	Minimar Restaurant	40
11	Pasatiempos	42
12	Puro Beach Club	44
13	Puro Oasis Urbano	48
14	Restaurante Ublo	52
15	Son Brull Hotel & Spa	54
16	Torrent Fals	60
17	Virtual Beach Club	64

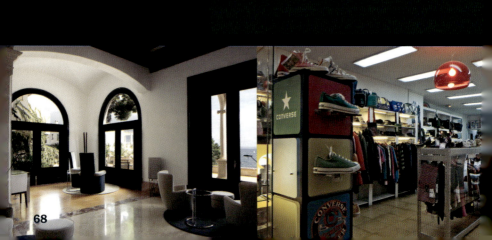

Agroturismo
Can Parramatta

Design: Adriana Gárate

Ctra. Sa Rota den Cosmi, 63 | 07840 Santa Eulària des Riu, Ibiza
Phone: +34 971 336 943
www.parramatta-ibiza.com
Opening hours: Every day 8 am to 3 pm, 6 pm to 11 pm
Special features: Rural hotel including massage, yoga sessions, diving classes, horse riding

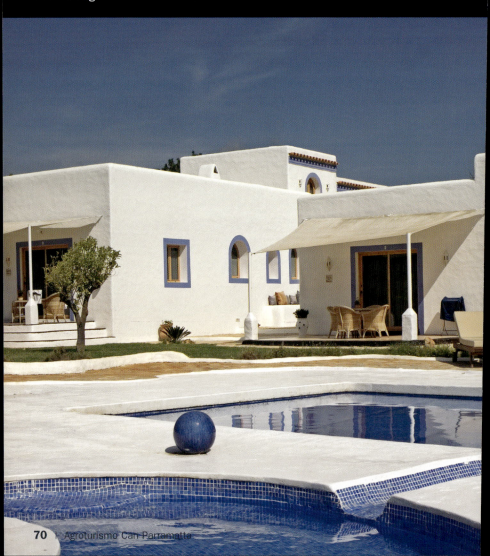

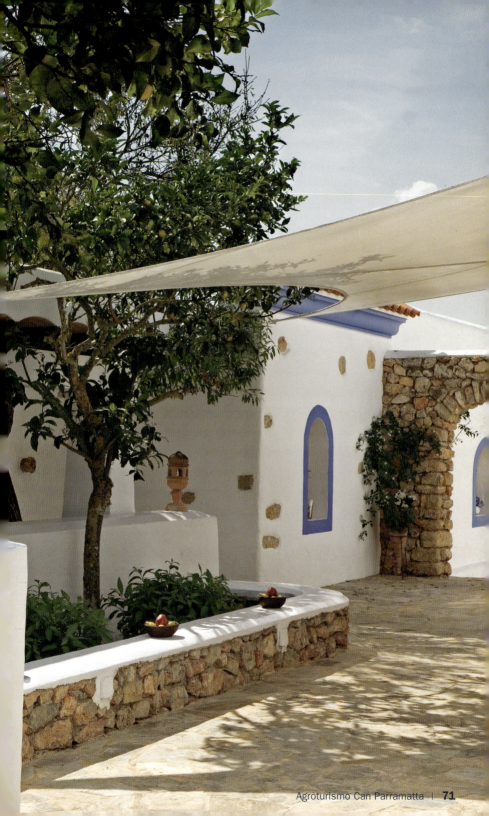

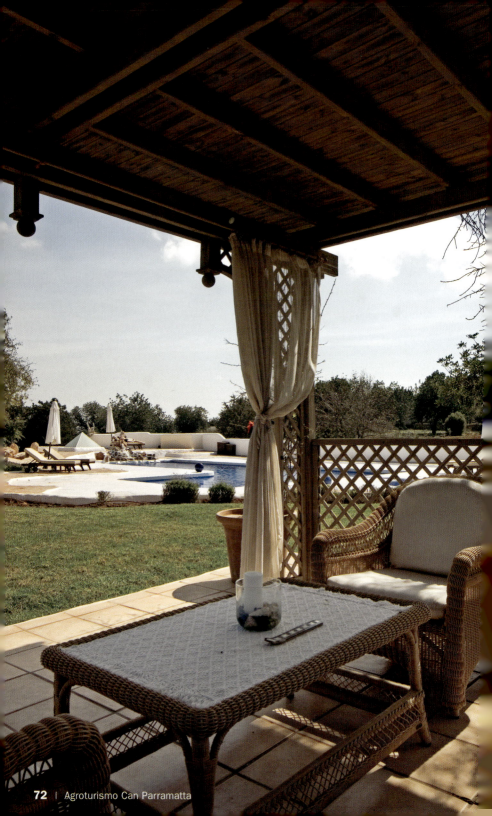

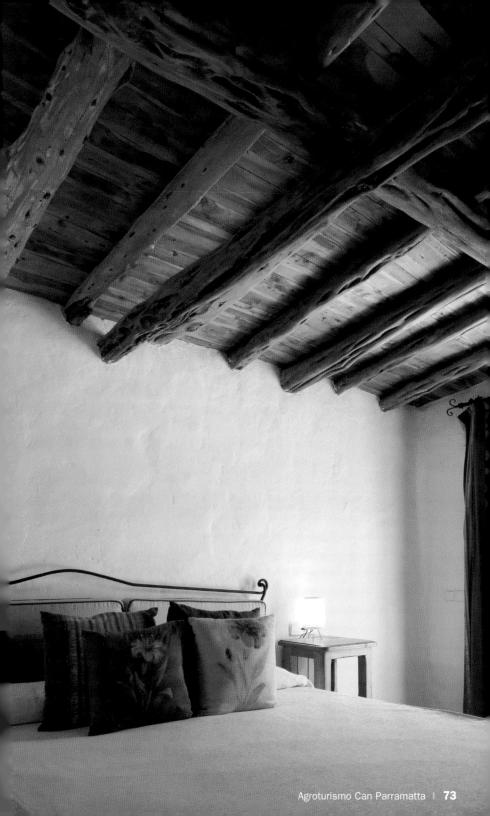

Atzaró

Architect: Abraham Ariel | Design: Philip Gonda

Ctra. Sant Joan, km 15 | 07840 Santa Eulària des Riu, Ibiza
Phone: +34 971 338 838
www.atzaro.com
Opening hours: Every day. Restaurant closed from the 1st of November until 28th of April
Special features: Hotel with Ibizan, African and Asian ambiences each with their own private terrace

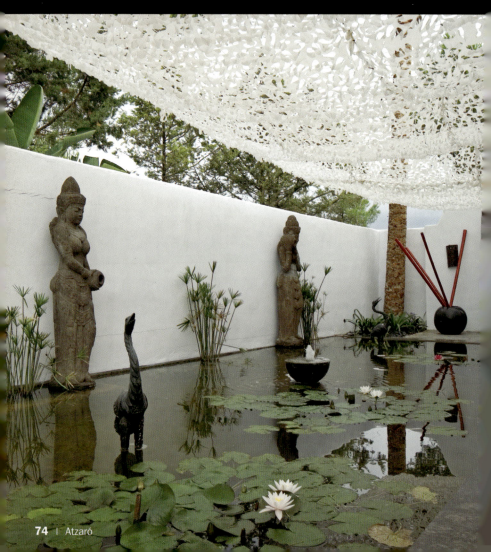

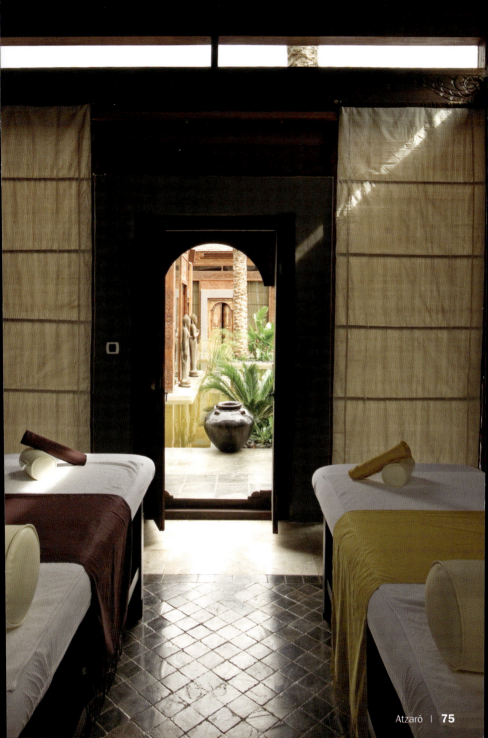

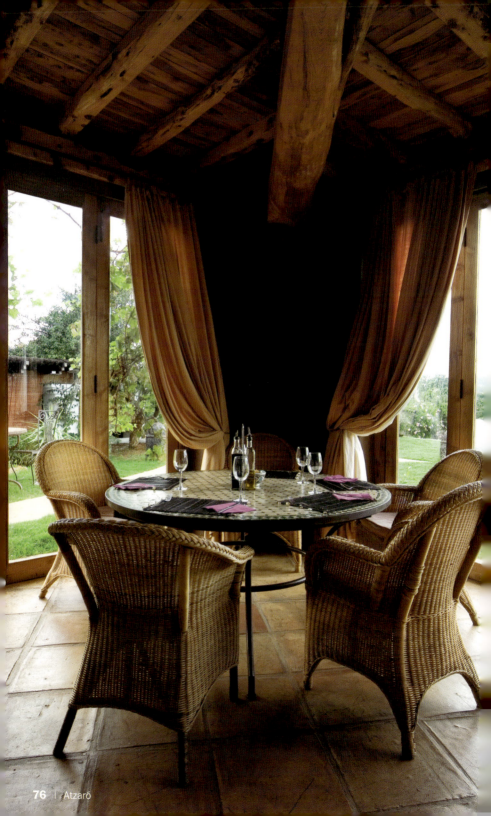

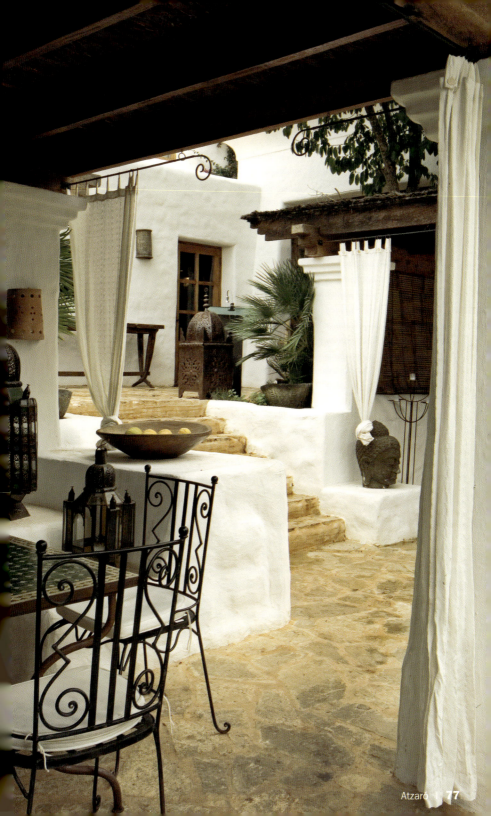

Bambuddha Grove

Design: John Moon

Ctra. Sant Joan, km 8,5 | 07840 Santa Eulària des Riu, Ibiza
Phone: +34 971 197 510
www.bambuddha.com
Opening hours: Summer, every day 8 pm to 4 am; winter, Tue–Sat 8 pm to 4 am
Special features: An original offer with a number of different ambiences: Banjak, Goa garden bar, Moonlight bedroom lounge, Siam cocktail bar, sushi bar and Khajurako lounge bar

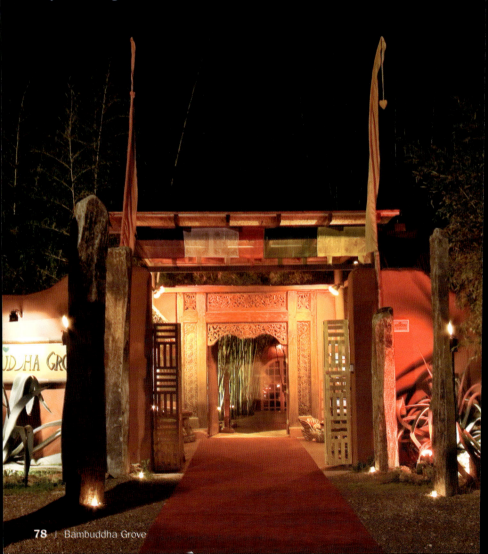

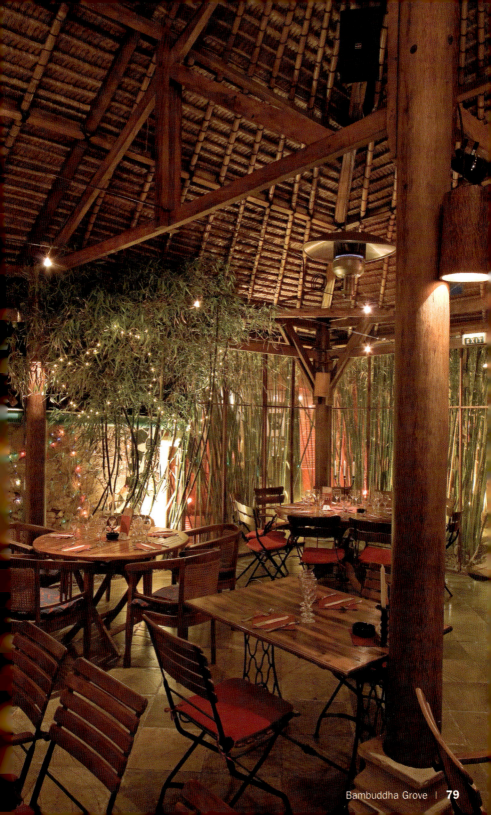

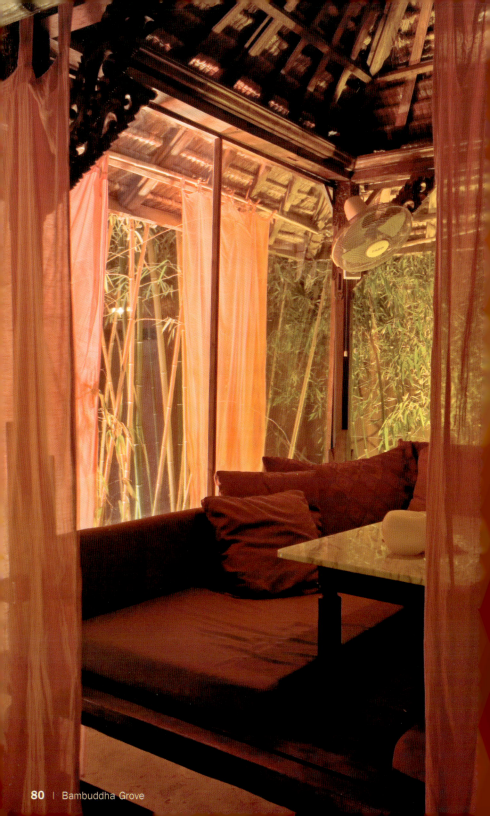

Blue Marlin

Design: Bruno Reymond

Cala Jondal | 07830 Sant Josep de sa Talaia, Ibiza
Phone: +34 971 410 117
www.bluemarlinibiza.com
Opening hours: Every day 10 am to 6 am. Restaurant 12:30 pm to 7 pm, 8:30 pm to 12:30 am
Special features: Night and day club including two outdoor bars, one cocktail beach bar, a restaurant terrace bar and an indoor night time events bar

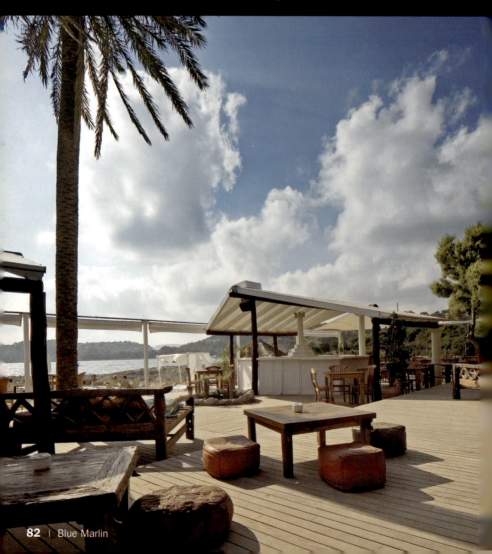

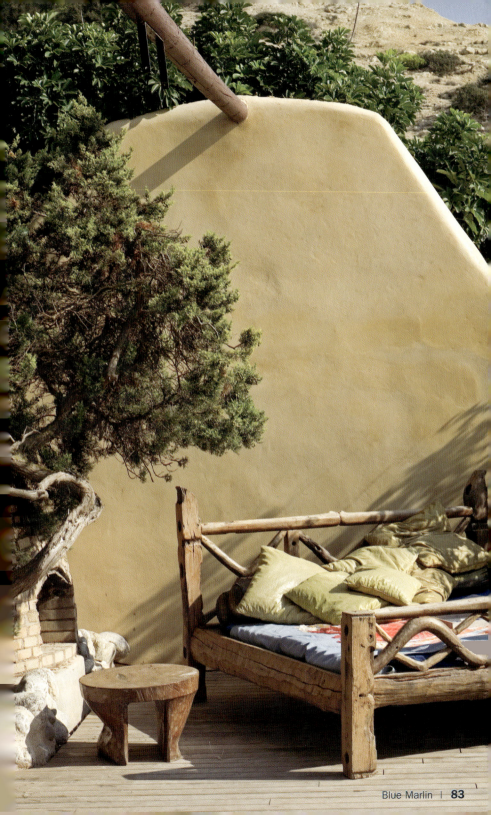

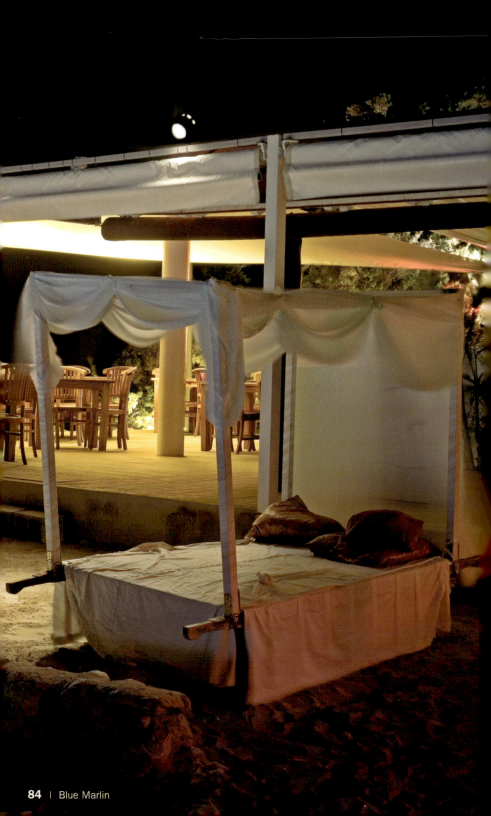

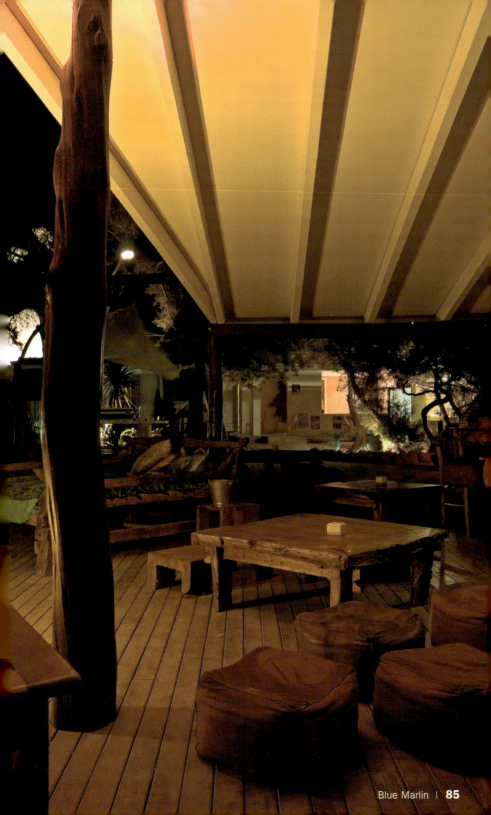

Boutique Hotel
Ses Pitreras

Design: Joan Lao

c/ Valladolid, 1-3 | 07839 Sant Agustí des Vedrà, Ibiza
Phone: +34 971 345 000
www.sespitreras.com
Opening hours: Every day, open 24 hours
Special features: Unique family run boutique hotel located close to some of the top beaches in Ibiza

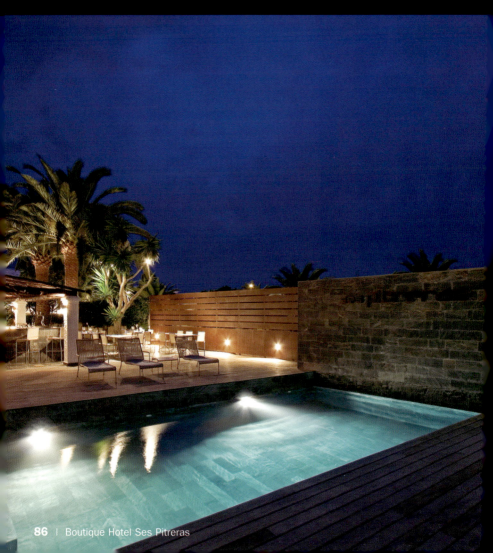

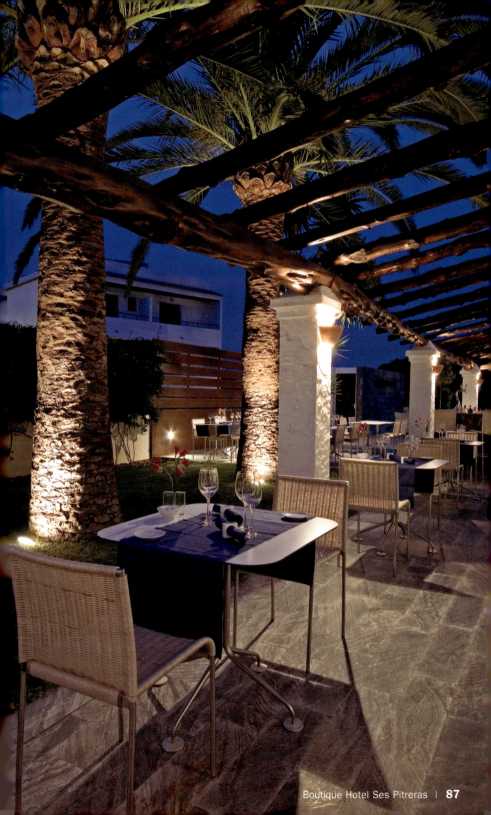

Cala Comte

Sant Josep de sa Talaia, Ibiza

Special features: Beach and sea with interesting rock formations. Overlooks the island of S'Esparta

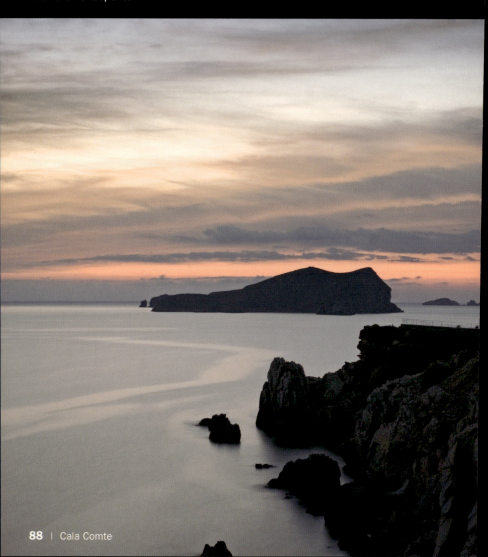

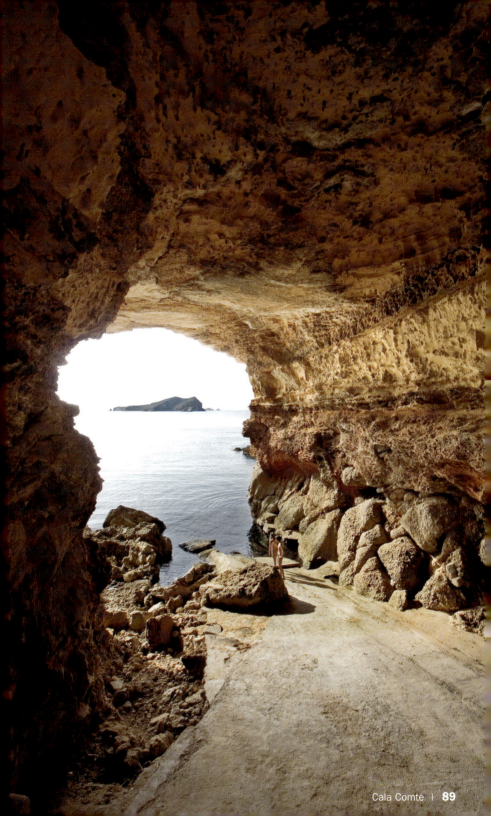

Cala Es Portixol

Sant Joan de Labritja, Ibiza

Special features: A near circular, quiet beach in the northern part of the island, surrounded by rocks, alongside picturesque fishermen's cottages

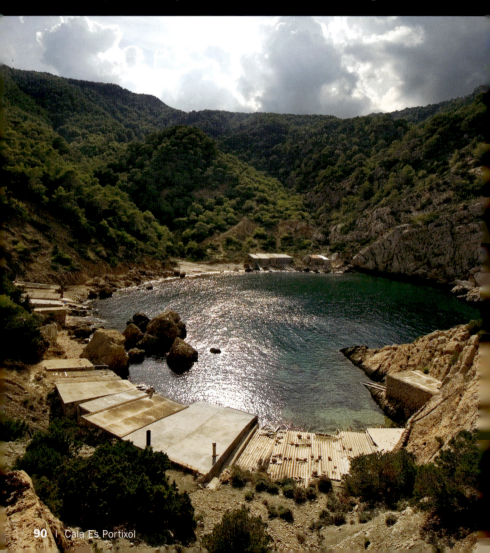

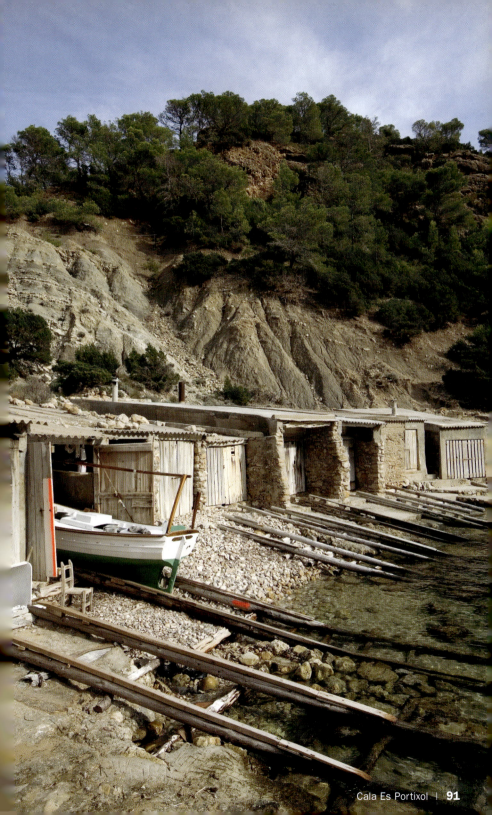

El Hotel Pachá

Architect: José Ferrer Llaneras | Design: Ricardo Urgell, Javier Reales

P.º Marítimo s/n | 07800 Ibiza
Phone: +34 971 315 963
www.elhotelpacha.com
Opening hours: Every day 10 pm to 3 am
Special features: Beachfront location, featuring suites with Jacuzzis on the terraces, restaurant and wellness room

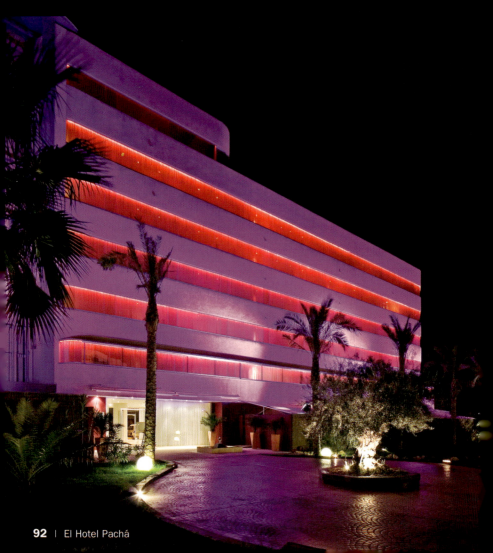

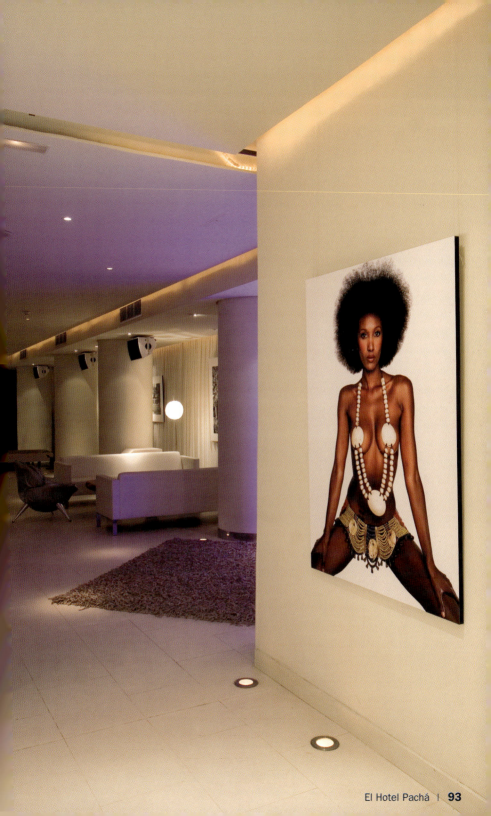

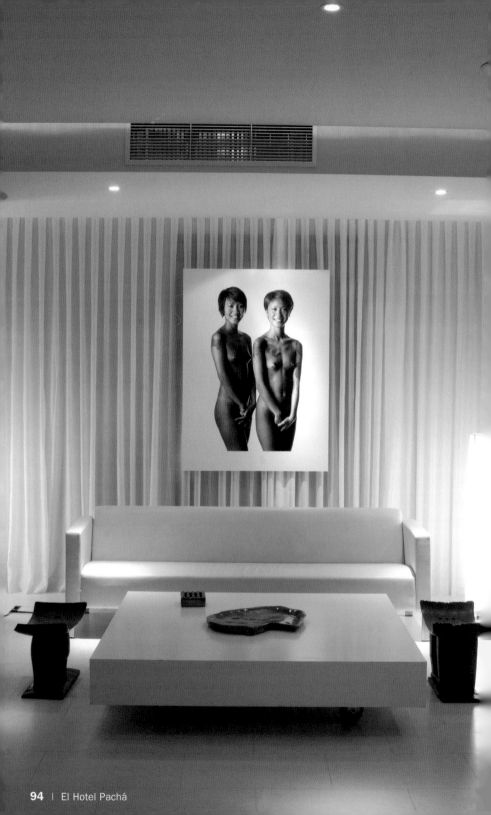

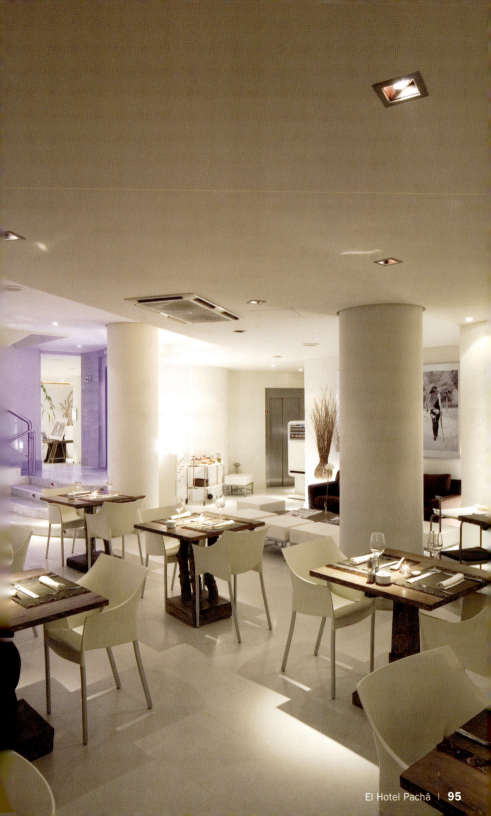

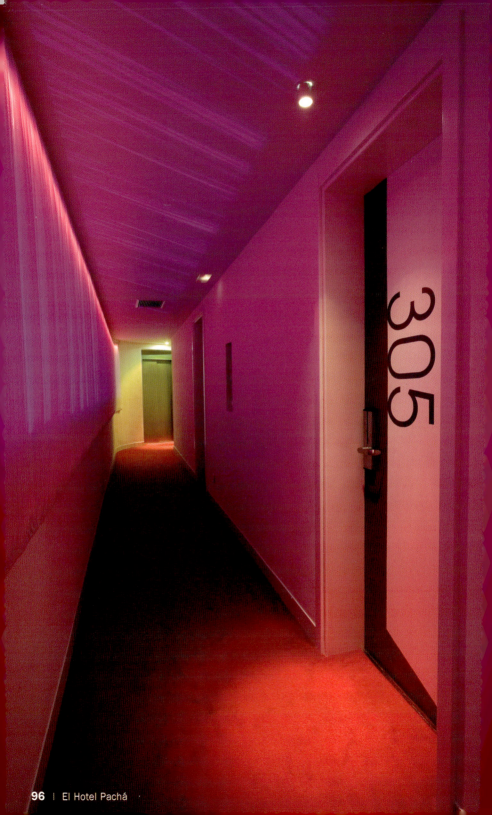

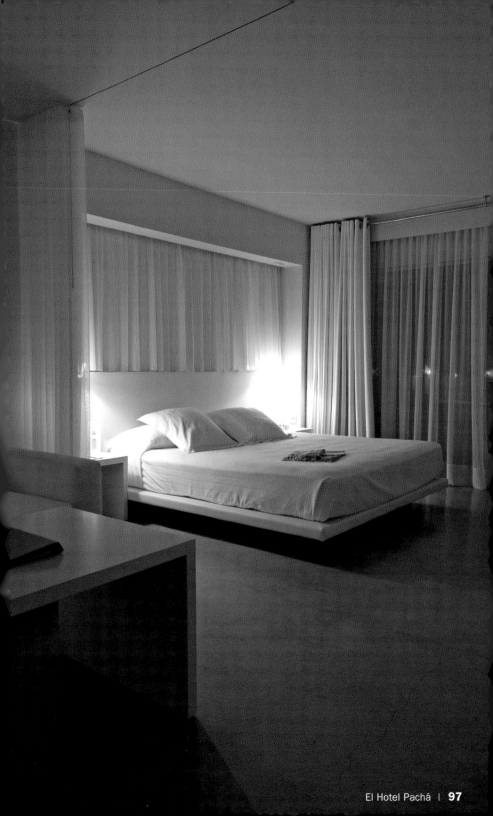

Es Vivé Hotel

Interior design: Rodrigo Fisher

c/ Carles Roman Ferrer, 8 | 07800 Ibiza
Phone: +34 971 301 902
www.hotelesvive.com
Opening hours: Every day 10 am to 6 pm
Special features: Hotel in the centre of Ibiza town, which is slick, chic and unique

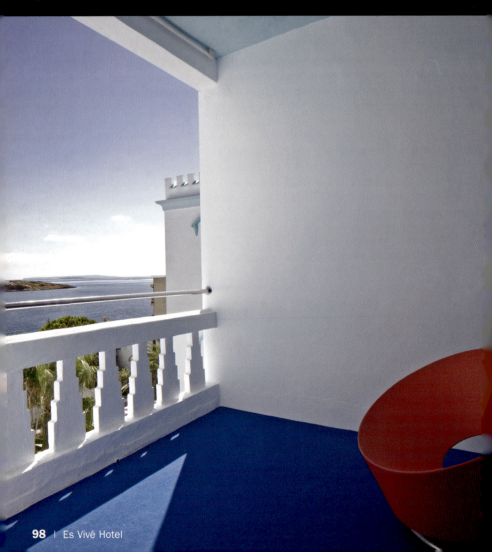

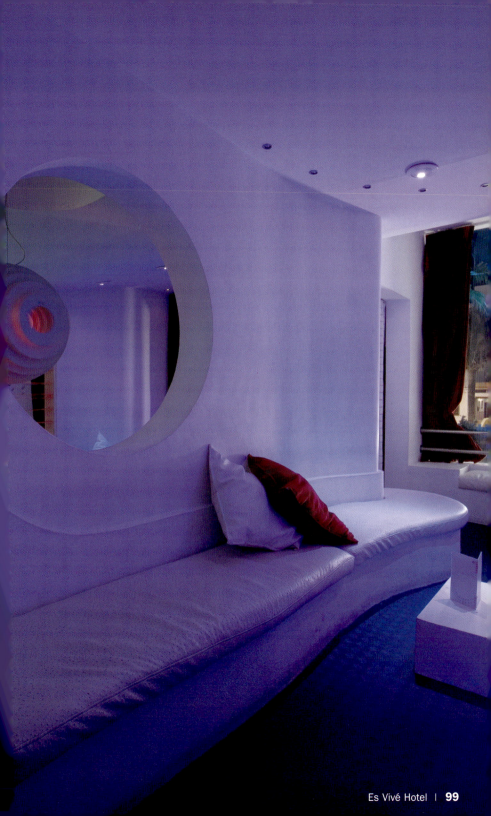

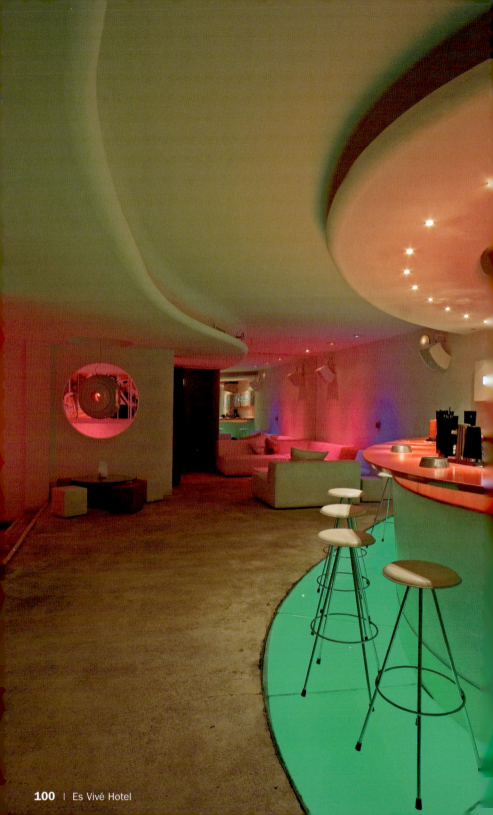

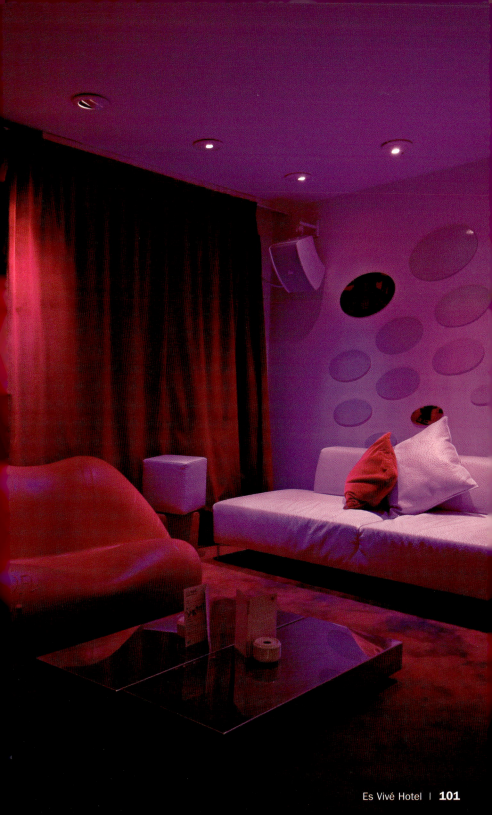

Hotel Agroturismo
Can Domo

Design: José Bernat, Alejandra Vermeiren

Ctra. Cala Llonga, km 7,6 | 07819 Santa Eulària des Riu, Ibiza
Phone: +34 971 331 059
www.candomo.com
Opening hours: Every day, open 24 hours
Special features: Restored 17th century building nestling in an olive tree plantation

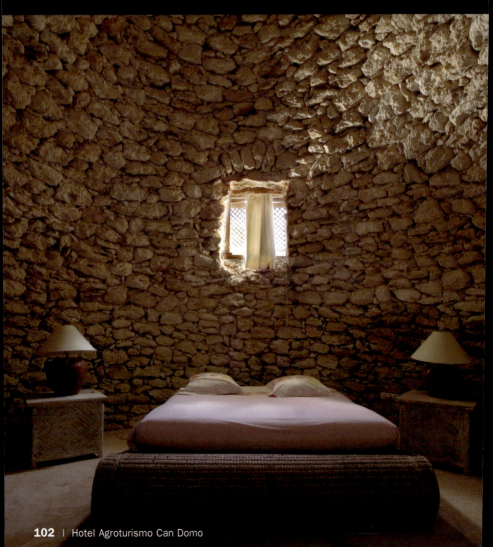

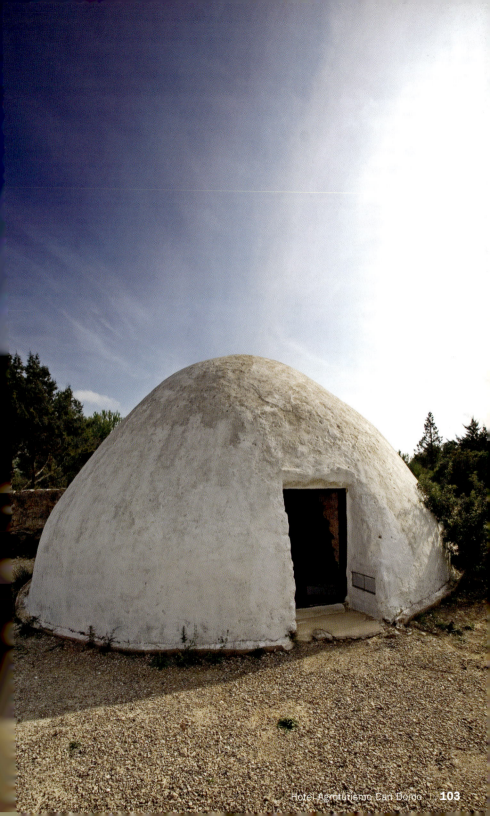

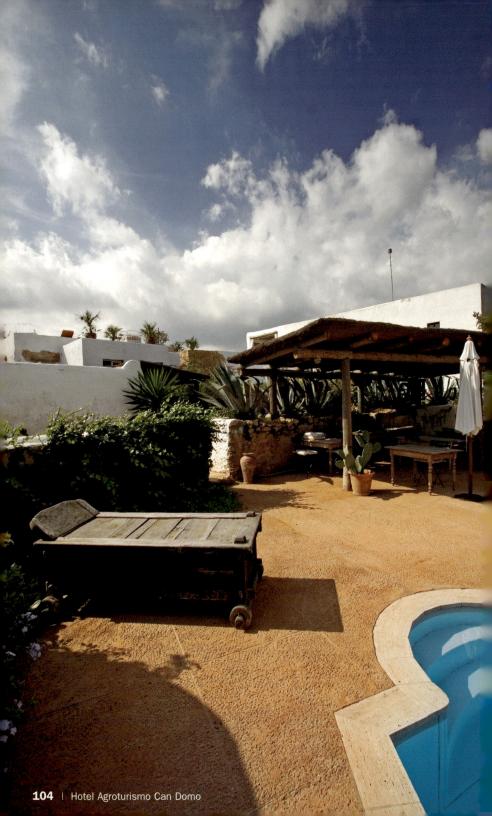

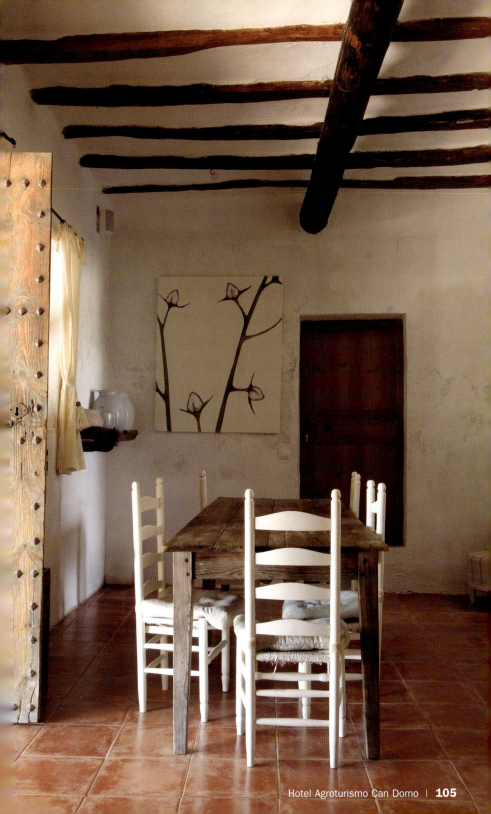

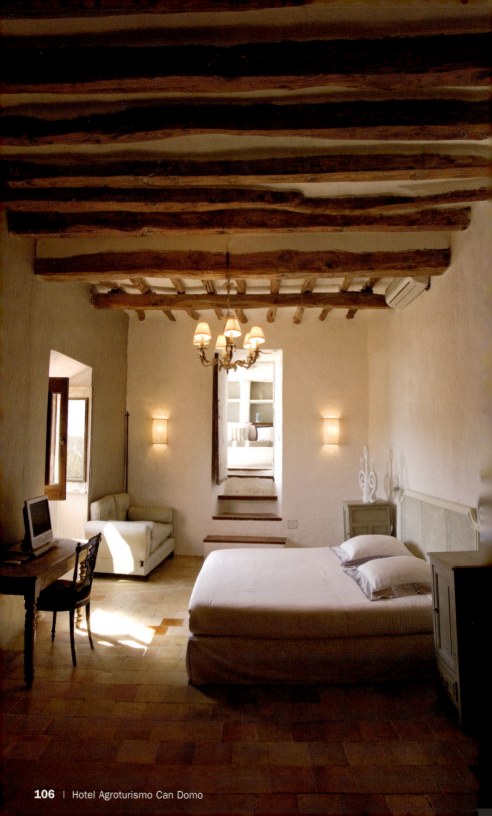

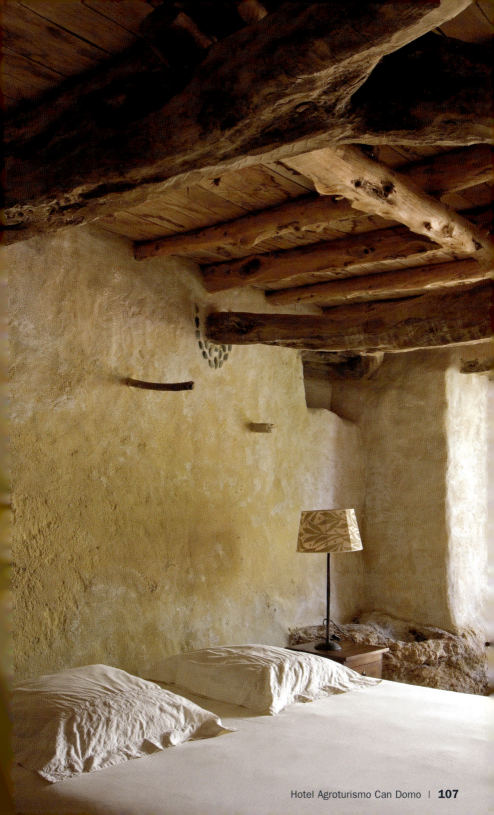

Hotel Hacienda
Na Xamena

Design: Daniel Lipszyc

Urbanización Na Xamena | 07815 Sant Miquel de Balansat, Ibiza
Phone: +34 971 334 500
www.hotelhacienda-ibiza.com
Opening hours: Every day 11 am to 2 am
Special features: Spa and Thalasso therapy open to everybody, pools and waterfalls with sea views. Four restaurants serving varied fare

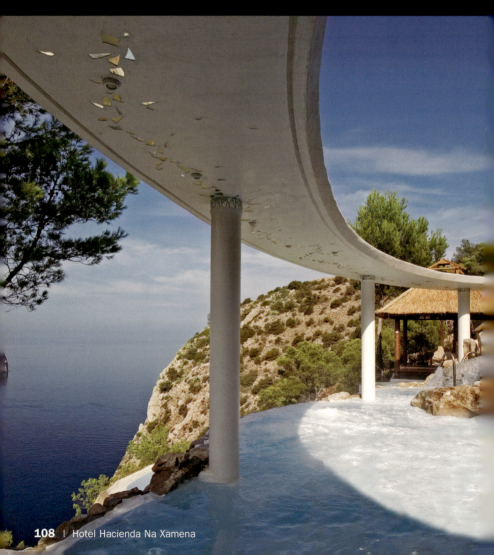

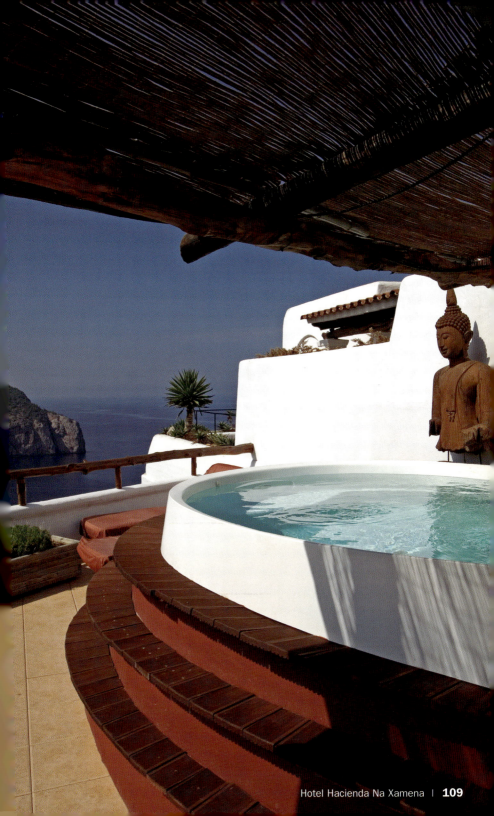

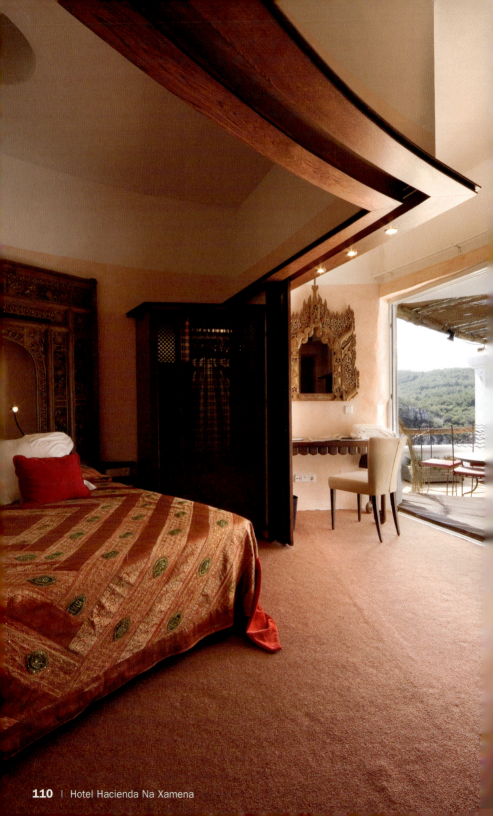

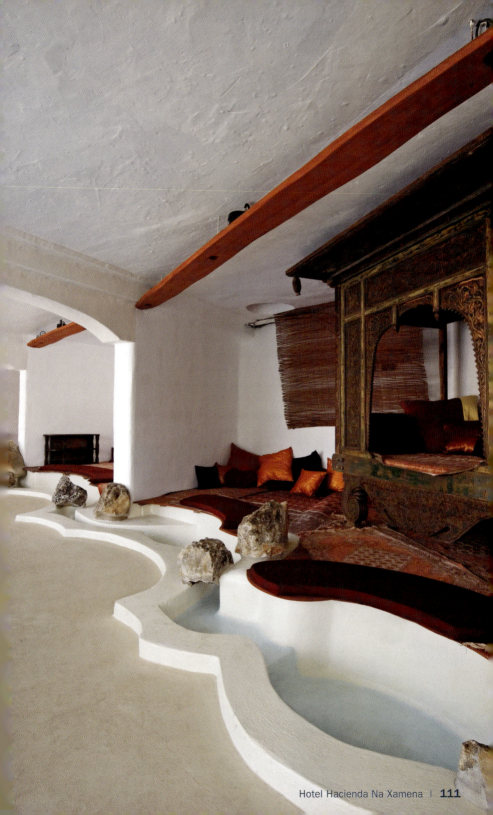

Indize

Design: Raúl Roviralta

Ctra. Puig d'en Valls, 2 | 07800 Ibiza
Phone: +34 971 193 381
indize@arrakis.es
Opening hours: Mon–Fri 10 am to 2 pm, 5 pm to 8 pm; Sat 10 am to 2 pm
Special features: A shop that sells Orient inspired ethnic, Asian and colonial furniture and decorative accessories

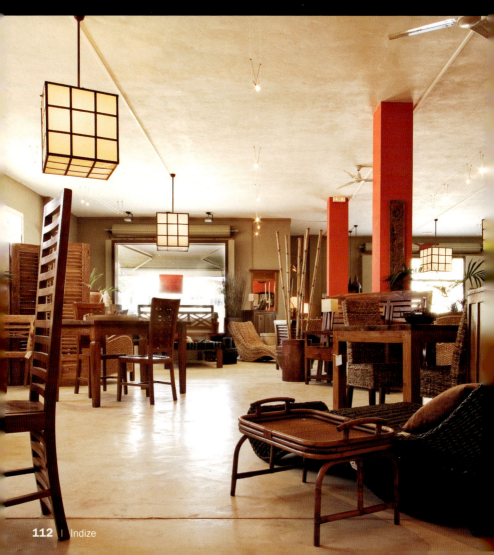

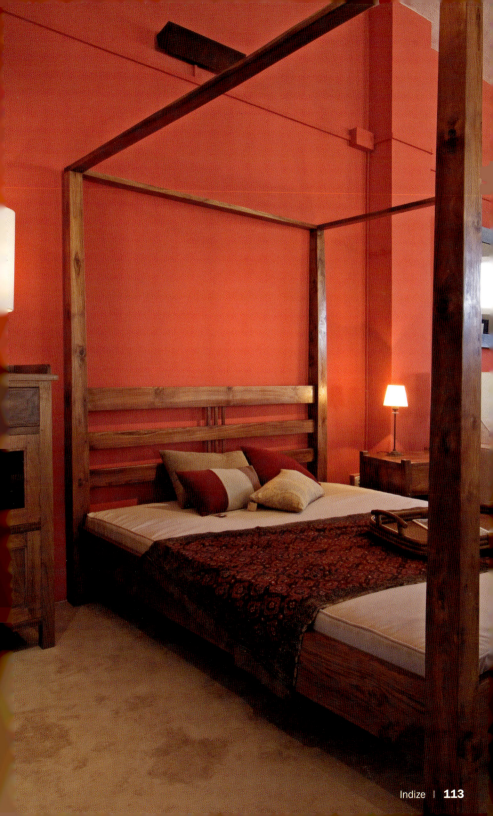

KM5 Lounge

Design: Olivier Mourao, Bruno Reymond

Ctra. Sant Josep, km 5,6 | 07817 Sant Josep de sa Talaia, Ibiza
Phone: +34 971 396 349
www.km5-lounge.com
Opening hours: Open from 29th of April until 8th of October. Restaurant, 8 pm to 1:30 am. Bar & lounge, 8 pm to 4 am
Special features: Luxurious Bedouine style oasis comprising a candle-lit lounge garden with sofas and cushions, an art gallery and shop

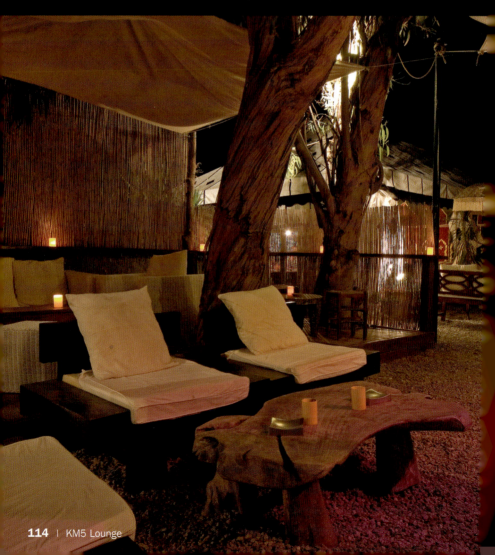

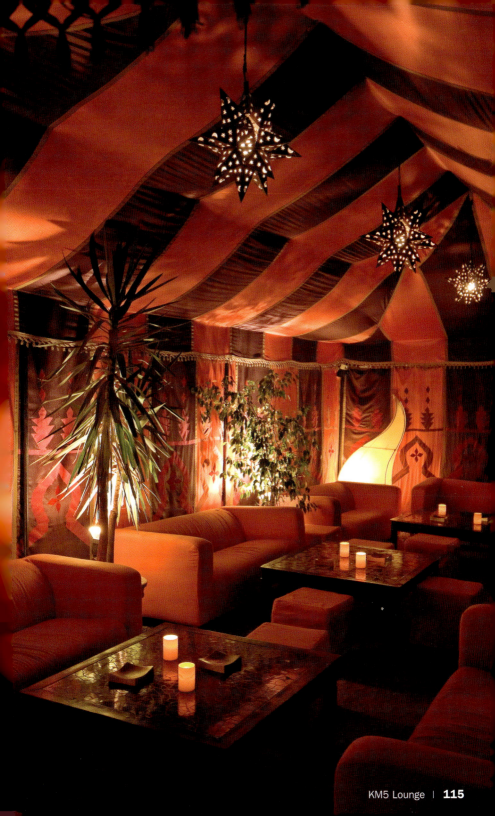

Kumharas
Sunset Café

Design: Miguel Maymó

Port des Torrent, Cala Bou | 07820 Sant Antoni de Portmany, Ibiza
Phone: +34 971 805 789
www.kumharas.org
Opening hours: From the 1st of May until the end of October 10 am to 4 am
Special features: Intimate restaurant where local produce is fused with international flavors in the creation of Asian dishes and author cuisine

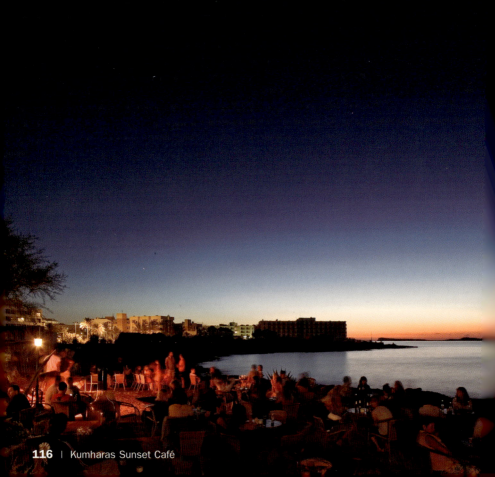

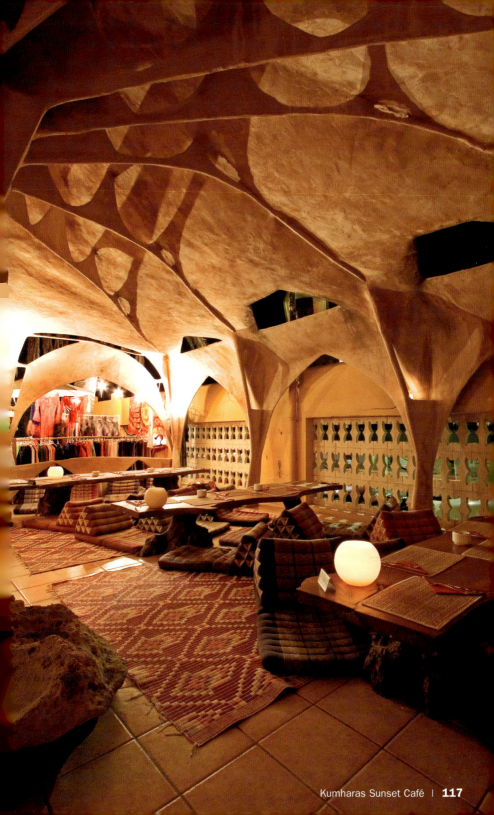

Pachá Ibiza

Architect: Jorge Goula | Design: Ricardo Urgell

Av. 8 de agosto, 27 | 07800 Ibiza
Phone: +34 971 313 612
www.pacha.com
Opening hours: Summer, everyday noon to 6 am; winter, Thu–Sat midnight to 6 am
Special features: Club that is originally based on the simplistic Ibizan white-washed style

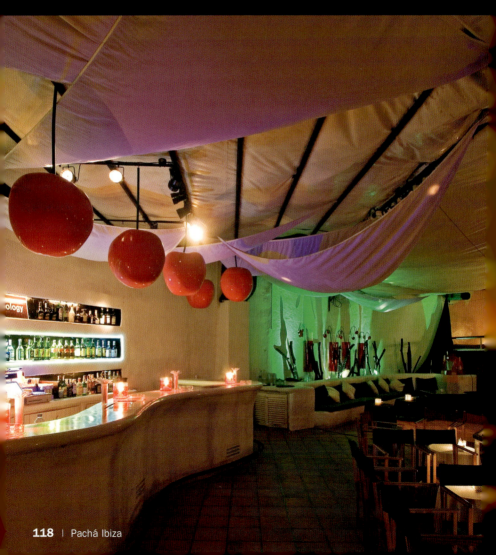

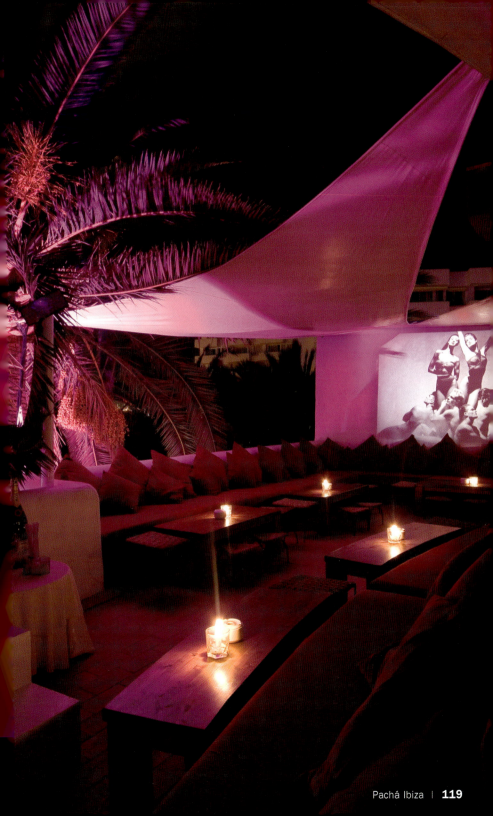

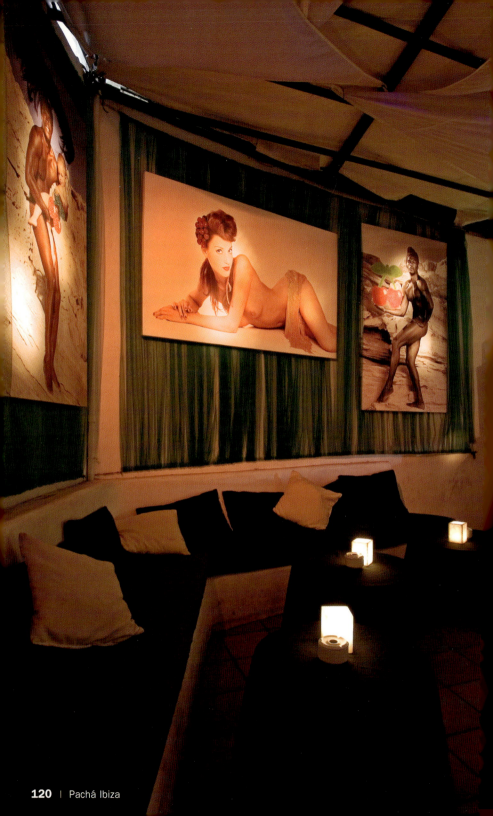

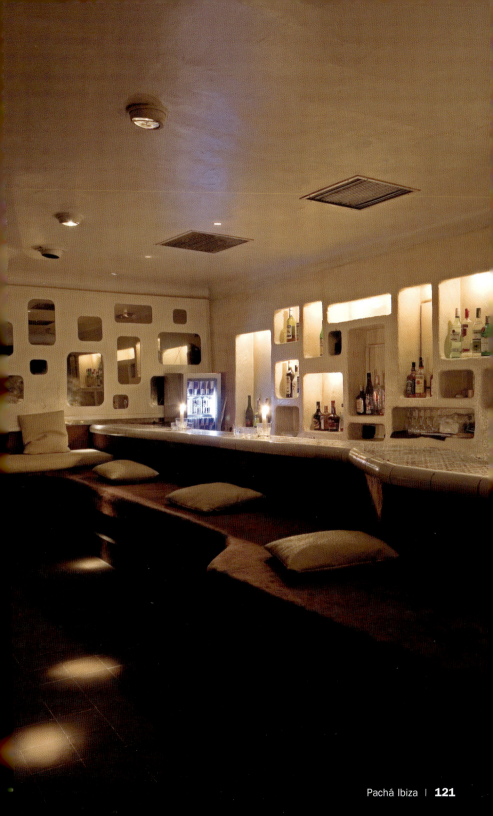

Special features: very long sandy beach bordered by pines, perfect for body-surfing and surrounded by exclusive bars which play music throughout the day. Very frequented by families, nudists, hippies…

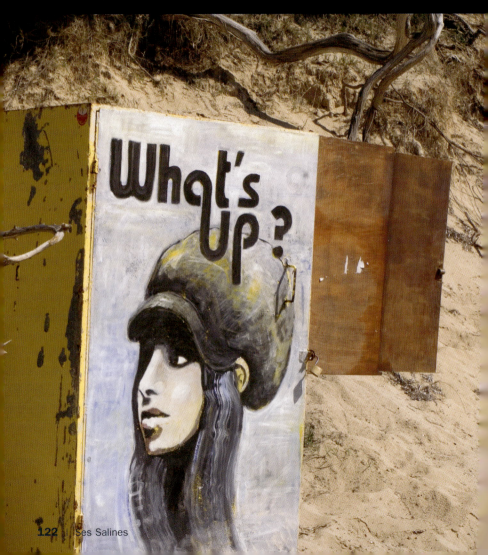

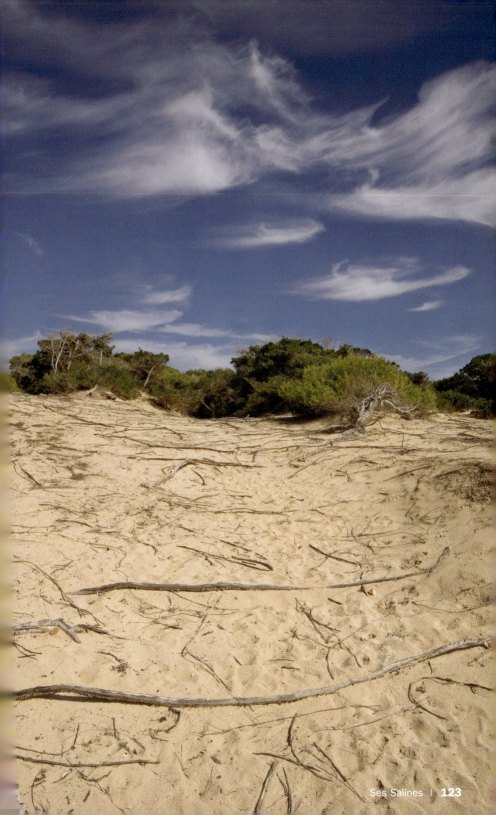

Space

Design: Jaime Romano

Playa d'en Bossa | 07817 Sant Jordi de ses Salines, Ibiza
Phone: +34 971 396 793
www.space-ibiza.es
Opening hours: From June to September, every day 8 am to 17 pm, midnight to 6 am
Special features: Best club in the world in 2001 Dancestar Awards. Five different ambiences and summer terrace

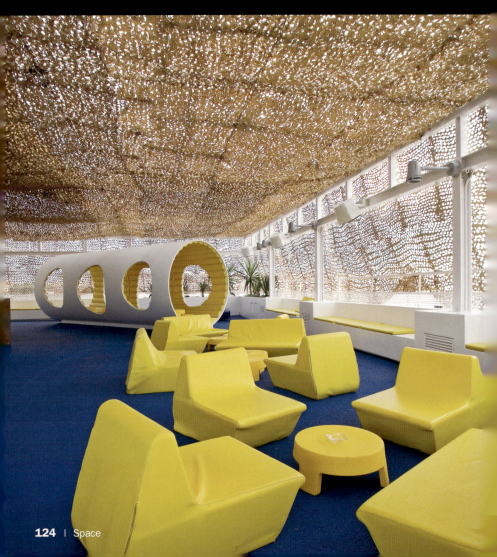

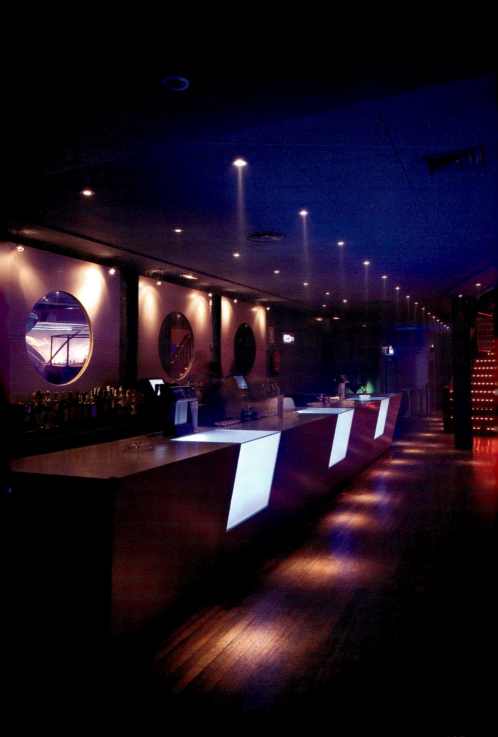

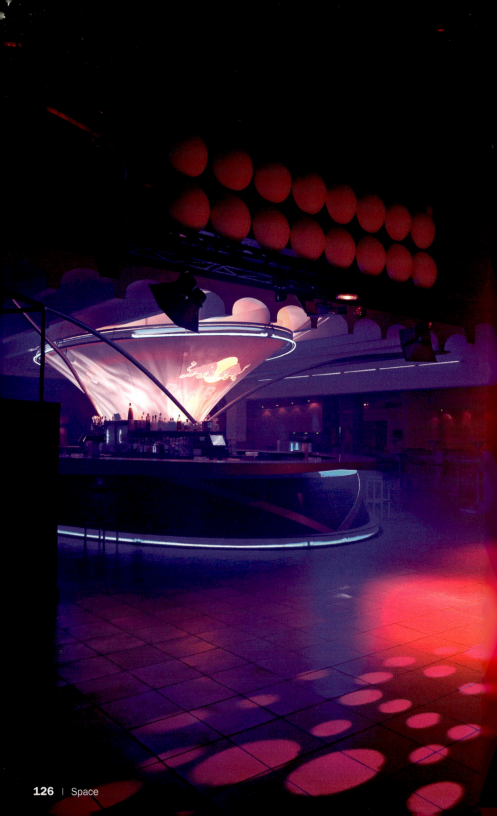

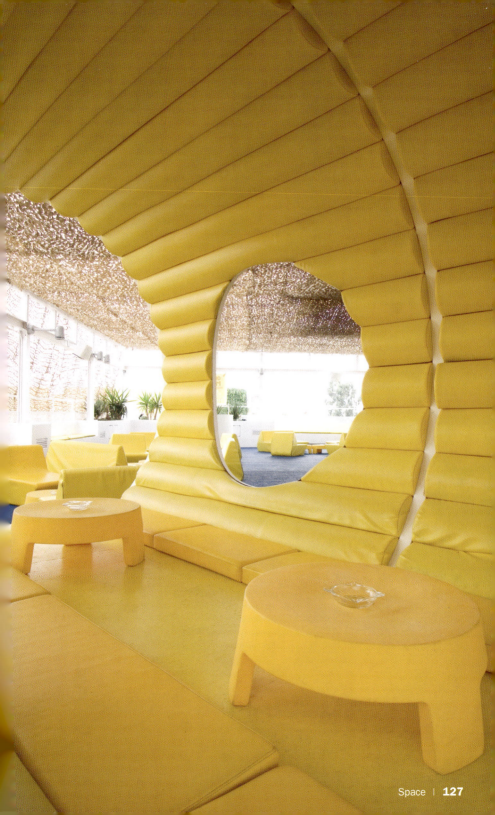

6 km from Ibiza on the road to Sant Joan | 07800 Ibiza
Phone: +34 686 351 098
www.villarocaibiza.com
Opening hours: Every day, open 24 hours
Special features: Bauhaus inspired ultra-modern country villa carved in solid rock. Sizeable swimming pool with waterfalls, hidden cave, swim-up bar and sub-aquatic pool windows

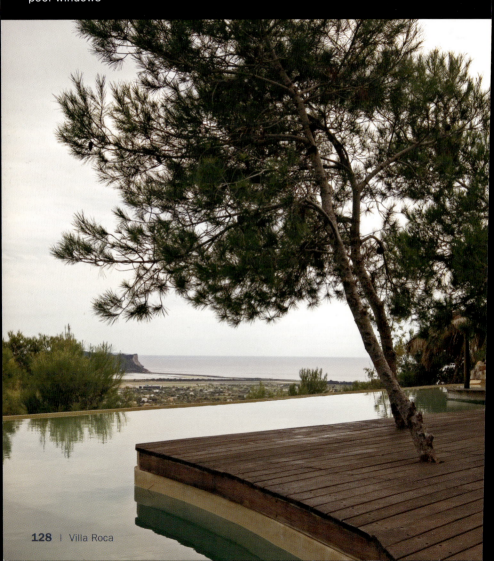

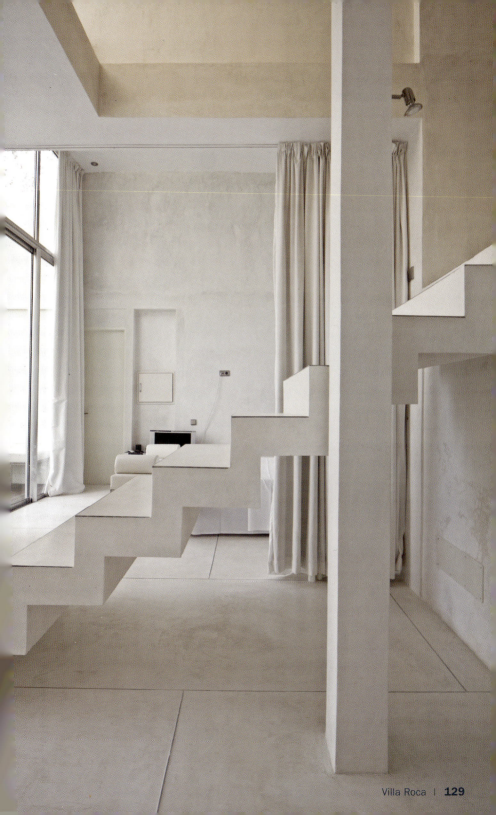

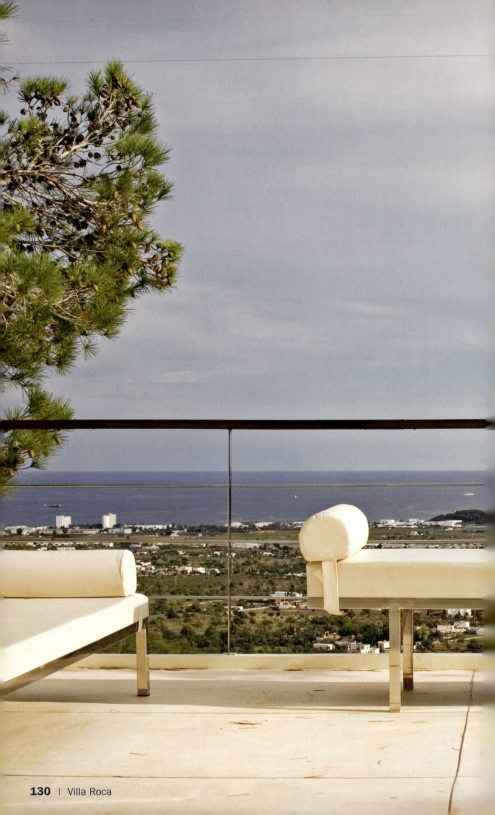

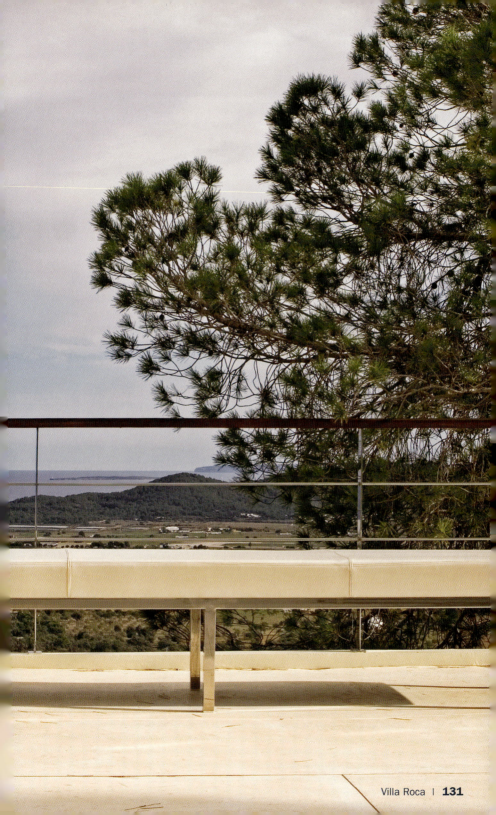

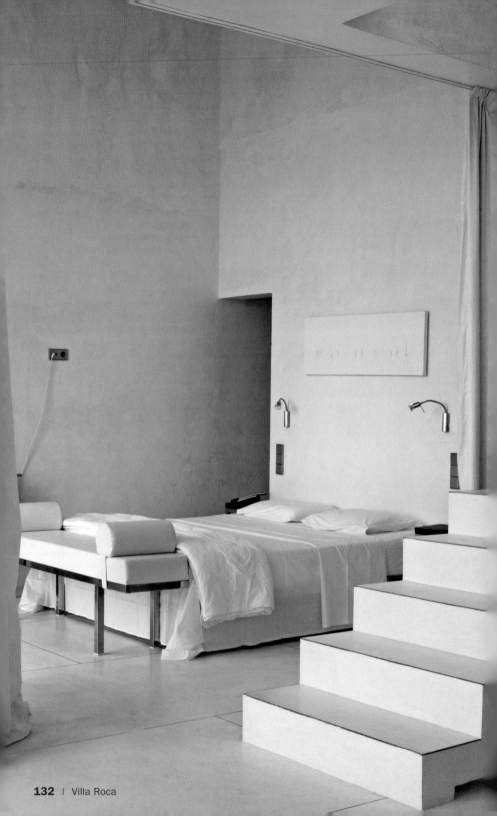

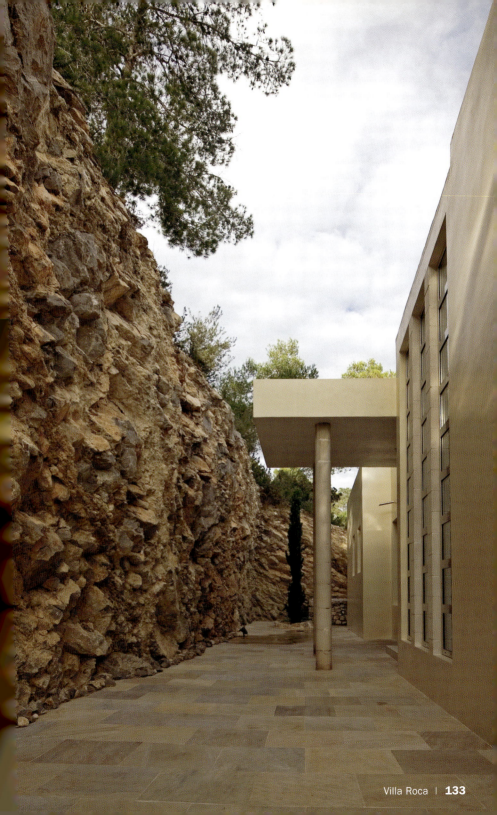

No.		Page
18	Agroturismo Can Parramatta	70
19	Atzaró	74
20	Bambuddha Grove	78
21	Blue Marlin	82
22	Boutique Hotel Ses Pitreras	86
23	Cala Comte	88
24	Cala Es Portixol	90
25	El Hotel Pachá	92
26	Es Vivé Hotel	98
27	Hotel Agroturismo Can Domo	102
28	Hotel Hacienda Na Xamena	108
29	Indize	112
30	KM5 Lounge	114
31	Kumharas Sunset Café	116
32	Pachá Ibiza	118
33	Ses Salines	122
34	Space	124
35	Villa Roca	128

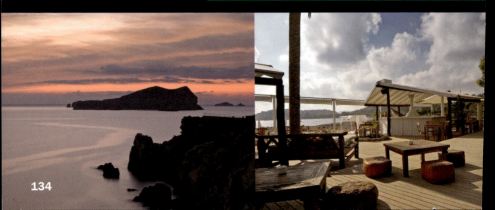

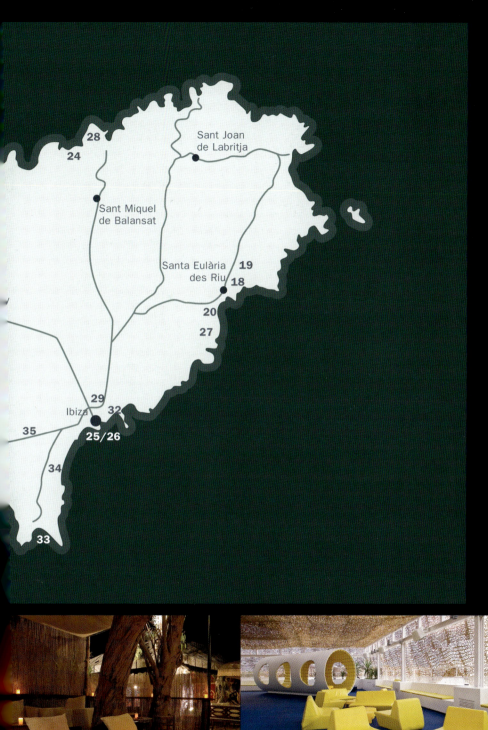

Cool Restaurants

Amsterdam
ISBN 3-8238-4588-8

Barcelona
ISBN 3-8238-4586-1

Berlin
ISBN 3-8238-4585-3

Brussels (*)
ISBN 3-8327-9065-9

Cape Town
ISBN 3-8327-9103-5

Chicago
ISBN 3-8327-9018-7

Cologne
ISBN 3-8327-9117-5

Côte d'Azur
ISBN 3-8327-9040-3

Frankfurt
ISBN 3-8327-9118-3

Hamburg
ISBN 3-8238-4599-3

Hong Kong
ISBN 3-8327-9111-6

Istanbul
ISBN 3-8327-9115-9

Las Vegas
ISBN 3-8327-9116-7

London 2nd edition
ISBN 3-8327-9131-0

Los Angeles
ISBN 3-8238-4589-6

Madrid
ISBN 3-8327-9029-2

Mallorca / Ibiza
ISBN 3-8327-9113-2

Miami
ISBN 3-8327-9066-7

Milan
ISBN 3-8238-4587-X

Munich
ISBN 3-8327-9019-5

New York 2nd edition
ISBN 3-8327-9130-2

Paris 2nd edition
ISBN 3-8327-9129-9

Prague
ISBN 3-8327-9068-3

Rome
ISBN 3-8327-9028-4

San Francisco
ISBN 3-8327-9067-5

Shanghai
ISBN 3-8327-9050-0

Sydney
ISBN 3-8327-9027-6

Tokyo
ISBN 3-8238-4590-X

Toscana
ISBN 3-8327-9102-7

Vienna
ISBN 3-8327-9020-9

Zurich
ISBN 3-8327-9069-1

To be published in the same series:
Dubai
Copenhagen
Geneva
Moscow
Singapore
Stockholm

COOL SHOPS

BARCELONA
ISBN 3-8327-9073-X

BERLIN
ISBN 3-8327-9070-5

HAMBURG
ISBN 3-8327-9120-5

HONG KONG
ISBN 3-8327-9121-3

LONDON
ISBN 3-8327-9038-1

LOS ANGELES
ISBN 3-8327-9071-3

MILAN
ISBN 3-8327-9022-5

MUNICH
ISBN 3-8327-9072-1

NEW YORK
ISBN 3-8327-9021-7

PARIS
ISBN 3-8327-9037-3

TOKYO
ISBN 3-8327-9122-1

COOL SPOTS

MALLORCA / IBIZA
ISBN 3-8327-9123-X

Size: 14 x 21.5 cm
5 $^{1}/_{2}$ x 8 $^{1}/_{2}$ in.
136 pp, Flexicover
c. 130 color photographs
Text in English, German, French, Spanish, Italian or (*) Dutch

teNeues